Draw NATURALLY

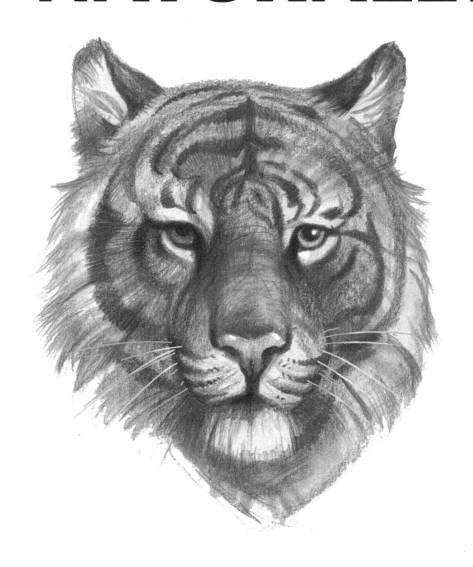

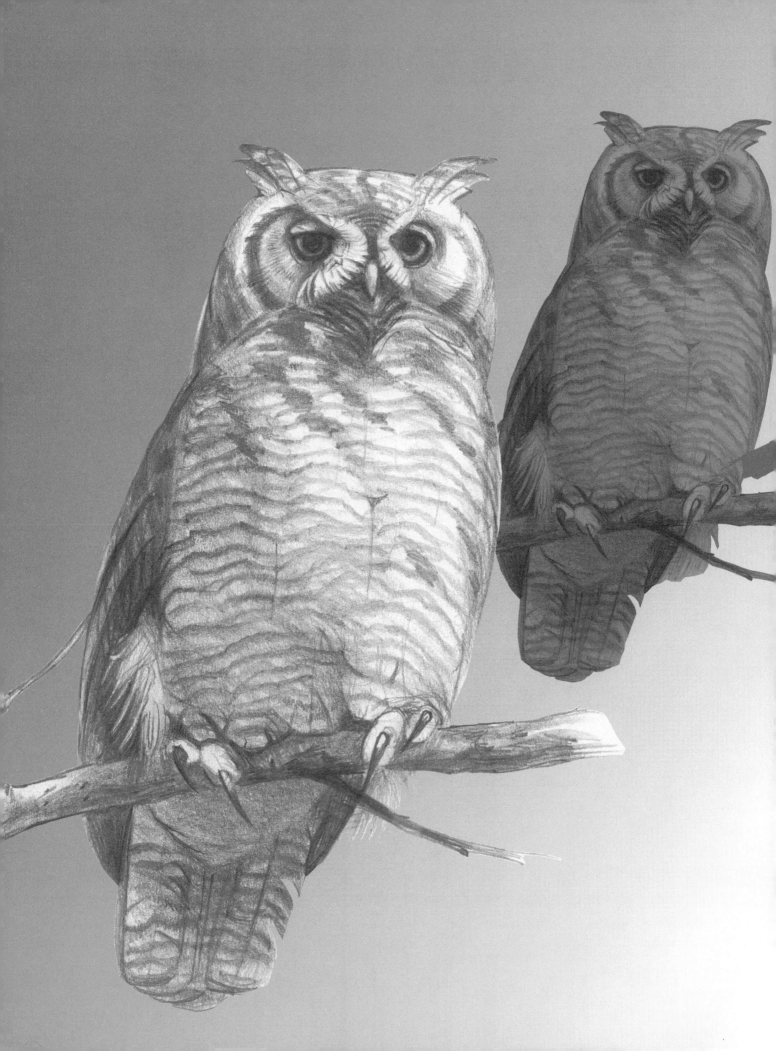

Draw
NATURALLY

How a New Way of Seeing
Can Improve Your Drawing Skills

ALLAN KRAAYVANGER

Watson-Guptill Publications/New York

*Those who are gifted with the ability
to see the simple shape of things
DRAW NATURALLY.*

The rest of us struggle.

*This book is dedicated to humble, serious students of all ages.
They teach us more than we teach them!*

Senior Acquisitions Editor: Joy Aquilino
Edited by Laaren Brown
Designed by Sivan Earnest
Graphic production by Hector Campbell

First published in 2004 by
Watson-Guptill Publications,
A division of VNU Business Media, Inc.,
770 Broadway, New York, NY 10003
www.watsonguptill.com

A catalog record is available from the Library of Congress.

ISBN 0-8230-1378-2

Manufactured in the United States of America

First printing 2004

1 2 3 4 5 6 7 8 9/12 11 10 09 08 07 06 05 04

Contents

 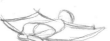

Introduction: Shape Is Everything

"Shape is everything." I often wonder if the artist who first said this to me really knew the full truth of these words. Most of us use the word "shape" so often in its simplest context that we never give any thought to the fact that working with shapes really is everything. It is all that the artist does.

When we begin a picture, we start out with a simple shape, usually rectangular, and work from that. When we add anything to the drawing, we are simply breaking up the basic shape into other, smaller shapes. When we add color or texture to any area of our painting, we are simply modifying a shape. The shape contains the color or texture; it is the dominant factor. When we finish the picture, we find that we have done nothing more than orchestrate shapes of varying colors, values, and textures. Simplified shapes also hold the key to most of the problems we face when drawing anything—from landscapes to figures.

Everything you see, everything around you, is made up of shapes of a given value or color next to the contrasting value or color of another shape.

Your mind does fascinating things with shapes. Remember how, as a child, you enjoyed looking up at the shapes of clouds and seeing bears, goblins, and other intriguing things?

When I was a boy of around seven or eight years, there was a little feature in our daily newspaper called, I think, "Wiglems." The artist who created this daily puzzle drew a simple, nonspecific shape, and we readers were supposed to finish it with whatever details we imagined he was thinking of when he drew it.

The next day the newspaper would publish his finished piece, along with a new shape for us to work on.

The results were amazing. My friends and I tried to solve the puzzles many times, and I don't remember anyone ever solving it the way the Wiglems artist did. We all saw something different in that same shape. Our minds have an endless capacity for creative imagination when confronted with simple shapes.

Drawing is a language—the oldest visual way of communicating human thoughts, or of describing the things we see around us. Shapes, lines, tones, and colors are the alphabet for this language. When you look at a drawing, you are actually reading, deciphering the clues that the artist put down for you.

In this book, we are going to approach the study of drawing from a completely different angle than usual to get you to see, think, and draw naturally, using shapes. I am going to prove to you that all it takes to learn to draw well is to understand and get control of shapes. If there is any magic or special gift needed to create art, you will find that magic here, in this fascinating world of shapes.

Drawing and Painting

"Drawing" is a word of many meanings. Just one generation ago, drawing had a very clear, specific meaning when used by an artist. In addition to the usual meaning, when a painting was said to be "out of drawing," it meant that somehow the proportions were off, or skewed, or something else was wrong. In other words, something was wrong in the basic structure of the picture.

If a picture was "in drawing," the opposite was true, and things were structurally sound. And "good draftsmanship" implied the ability to put a solid, true structure under your work.

Recently, a young graduate of a well-known art school, the facilitator of an evening figure-drawing class, asked me what I meant when I said the draftsmanship in a painting we were looking at was solid. It was then that I realized that many schools were no longer teaching the fundamentals of art the way they had for hundreds of years.

In many schools today, the emphasis is on creativity, design, and individuality of expression. These are all extremely important ingredients in the mix of a solid art education.

But why throw the baby out with the bathwater? Solid draftsmanship is the cornerstone of them all, and even abstract expressionism benefits from good drawing, or suffers from its lack. Art schools obviously still believe this to some degree, because most of them still offer a figure-drawing class. But in those classes, the students are expected to draw what they see in front of them, and they struggle heroically to get something worthwhile without the benefit of the basic fundamentals that every aspiring artist of the past had to learn.

Basic drawing skills are so important that it is practically impossible to do a good painting without them, and learning to paint is almost automatic when you have mastered them. There is little point in picking up a brush until you have reached a certain level of drawing ability. You are actually learning most of the skills of painting when you are drawing. Whether you are using paint or drawing media, you are drawing when you are trying to decide where the next mark goes on your canvas or paper. Learn to draw naturally, and you will also be learning to paint naturally.

Shapes Versus Form

In this book, a "shape" is the flat, two-dimensional aspect of a thing.

A "form" is a solid, three-dimensional shape. Sculptors work with forms.

When you draw or paint, you work with shapes. You might be drawing something that looks solid, but in drawing or painting, you have only shapes to work with, since you are working on a flat surface. Those beautiful, solid-looking figures that Michelangelo did are really nothing more than flat shapes made to suggest forms. Good artists create form with shape so well that it becomes extremely difficult to see their images as the simple shapes they actually are.

It is this act of visualizing forms as shapes, or transposing shapes into forms, that makes drawing seem so difficult. It is also where artists will find most of their problems in drawing. Although I might use the word "shapes" when "forms" would fit the situation, I do so because I want you to begin thinking of forms as shapes first.

A clear understanding of the distinction between shapes and forms is key to everything we will be discussing in this book.

The black silhouette at top right is a shape. It has no depth or solidity and appears flat. Notice how much information you gain from this simple shape: You know instantly that this is a cat. The way the ears are positioned gives an idea of the animal's state of awareness. You can even imagine that the cat is sitting, even though the whole lower half of its body is not showing.

A simple outline, also called a contour, does pretty much the same thing. It still appears flat, and it still gives quite a lot of information. These three pictures are perfect side views, and they would become more complicated if you viewed the object from different angles; but an outline would still work in the same way. As you look around you, it will become apparent that some views are easier to "read" than others, and that your choice of the view of your subject—your relationship to your model—will have a great deal to do with the success of your drawing.

In this drawing, we see how little it takes to begin the visual transformation of a shape into a form. The addition of even a tiny amount of information inside the contour begins the process. Here, there are only a few simple lines inside the contour line, and you have already begun to accept the fact that this is a solid object.

There are many ways to make this transformation. Some are so effective that you no longer can think of the resulting drawing as simple shapes without great concentration. I call these little touches "clues." We will explore them later in the book.

It is obvious that this silhouette shows a cat. A flat cat. But your brain wants to see a fat cat.

This outline is also obviously a cat. Also flat . . . but your brain still wants to see a fat cat.

A few extra lines make this cat much less flat. Now it's fat! But is it really? It is still made of marks on a flat sheet of paper. What adds the sense of three dimensions? How much of the cat's form is "real" and how much is your brain filling in the details?

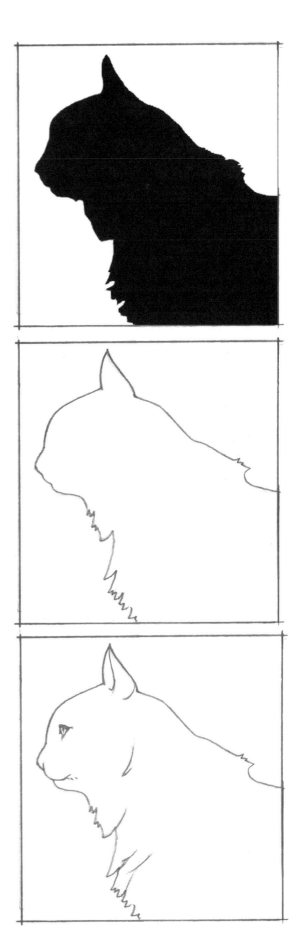

1 The Artist's Vision

From our very beginnings, the artists
among us saw things differently.
This chapter focuses on teaching
you to see things in a new way,
and introduces the first techniques
in drawing with shapes.

The Master's Vision

This drawing is a copy of a copy of a drawing by Rembrandt. Even so many steps removed from the master's original, you can see that shapes are all-important. Little details are totally irrelevant to good drawing.

Rembrandt was able to tell a whole story with the simplest shapes and lines. Study his work to develop the same kind of artistic vision.

This drawing does not show even one clearly defined detail; the closest it comes to showing a recognizable detail is the head of the central figure, and a closer look shows that that is nothing more than a few well-placed strokes. Yet this drawing sings out to us with its message. You can see figures sitting, standing, or kneeling. You can sense the movement of the crowd and the solidity of the structures in the background, and yet when you try to pick out any reasonably solid detail, you cannot do it—the detail slips away as you look.

The original drawing was done by one of the world's greatest masters. Rembrandt was perfectly capable of doing the finest detailed work, but he worked this way when he was building a composition for a painting, or when he was taking visual notes on a scene, or even when he was playing around with an idea.

To me, these little gems are the artist's greatest work. Study his drawings. At first, you might find his sketches simplistic; you might be more impressed with his more finished work, his paintings or his etchings. But as you mature and develop as an artist, you will become more impressed with these drawings and in what he is able to say with so few lines and tones. Notice the big simple shapes and how they convey the whole story because of their relationship to one another.

It takes a special vision to see things this way, and to draw with such economy and confidence. Those who are blessed with this vision draw naturally . . . the rest of us have to learn and practice to develop this remarkable grace.

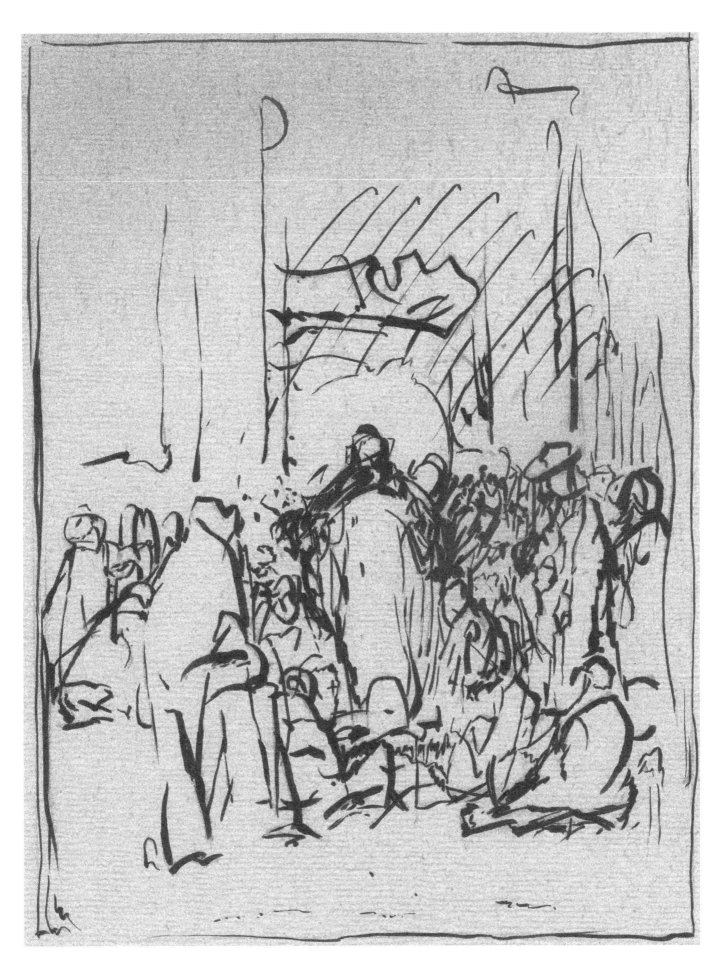

Shapes from the Past

Man has been making art for untold thousands of years. From the Stone Age to our age, every culture has had its artists, and you would expect to see dramatic changes and growth throughout the years. Yet when I look at the art produced through the centuries and compare it with what we are doing today, I have to conclude that art does not grow, it simply cycles. It seems no better today than it was in its earliest beginnings. It isn't even much different.

The one area where some noticeable growth has taken place is in representational art, because of the introduction of the photograph for study and the understanding of the laws of light and perspective. Could it be that except for a change in some of the materials and methods, no measurable progress has taken place in the fine arts over the last ten thousand years?

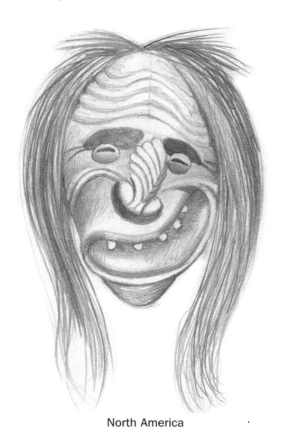

France

The art of the past, especially primitive art, is a gold mine for studying the use and function of shapes in the creation of all art. You will find every imaginable way of exploiting shapes in these masterpieces, from beautiful, sophisticated realism to the wildest, most imaginative distortions possible. Take your sketch pad and an open mind to a museum (or even a library) where you can find examples to study and work from. As you look at primitive art, think about the shapes and how the artist used them as he or she worked.

Here are four of my own sketches, each inspired by works of primitive artists. The originals span thousands of years and four separate cultures from opposite ends of the world. They were made to demonstrate the use of shapes in their creation and are not accurate copies. To me, their similarities are more striking than their differences.

After studying these, and other examples of artists' work through all of history, you begin to get some idea of the importance of shapes in the creation of all art. Basically, early artists really had only one element to

North America

work with, only one thing to modify, organize, and add their own personal vision or taste to. That element is shape. Yet by working with this single element, each succeeding generation left its own unique imprint on the history of art.

Two of the drawings here were made from sculptures, and two were made from flat drawings or paintings. In working from sculptures, you need to visually change forms into shapes, and then try to make them suggest forms again. Copying drawings is simpler: You reproduce the shapes in front of you.

An interesting process happens during and after this act of making shapes. The viewer's mind—yours, in this case—is eagerly cooperating with these attempts to solidify and turn these flat shapes into recognizable, fully rounded forms. Notice how you want to see the drawing of the mask at left as something solid, although it is nothing but gray and black flat shapes. You can't quite turn it solid, but the pull is there, and you get some enjoyable entertainment out of the struggle.

Now look at the drawing of the horses and bison. It is

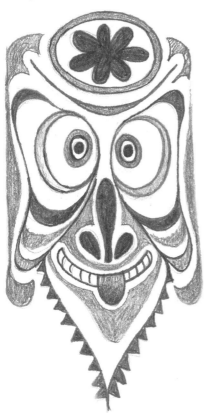

Solomon Islands

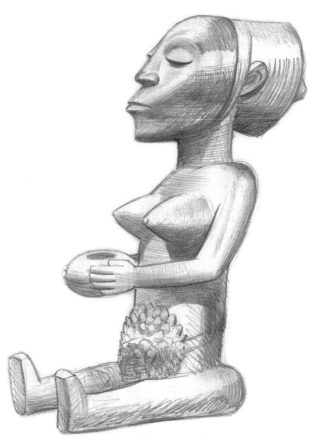

Africa

not difficult to sense the solidity and roundness of the animals. The simple fact that you recognize them and know they are supposed to be solid objects makes you want to see them as rounded, but they are nothing but flat outlined shapes with some simple tones in them.

Finally, look at the other two drawings. They are loaded with clues as to the solidity of these objects, from the imitation of light in the drawing of the African figure, to the sculptural modeling of the forms with tones in the drawing of the gruesome face. Both of these pictures show faces, and they have many similarities. But isn't it obvious which drawing was made from a three-dimensional mask and which from a flat picture? Once you have accepted a drawing as a description of a "whole," it becomes difficult to see it as the simple shapes that it really is.

The Island

A master teacher is available free to all of us. She has taught great artists since the beginning of time. She knows everything there is to know about beauty; in fact, she wrote the rule book for it. This great teacher is nature.

Without light, everything is one big black formless mass. But as the light increases, shapes are revealed in a definite order, and details gradually become clear.

Too many of us spend too little time outdoors, watching the seasons change, watching the sun rise and set, watching the way light changes throughout the day—that is, really looking at the amazing natural world around us. We spend most of the time in the studio, and more and more of us draw and paint from photographs rather than witness nature's handiwork for ourselves.

The Impressionists understood the value of observing nature firsthand. As a result, they created a new way of seeing and painting, and their works inspire us to this day. You can study nature anywhere, even in the heart of the city, but I find it best to visit the woods, the fields, or other natural places. I visit nature often. At these quiet times, away from the pressure of the modern world, the problems of the everyday world fade to their proper place in the scheme of things. If you relax and free your thoughts, fascinating insights pop into your mind.

One morning, as I often do when sleep eludes me, I walked down to a little lake in the park near my house. I sat on a bench overlooking the lake and let my mind wander. It was still pitch dark when I arrived, but soon the sun began to rise over the horizon on the far side of the lake. The little drama that unfolded then inspired this book, and demonstrates many of the points that I make in it.

Nature had just given me a handful of her precious nuggets. Without light, everything is one big black formless mass. But as the light increases, shapes are revealed in a definite order, and details gradually become clear. They never overpower the big shape that contains them. In the course of my experience looking at nature and seeing the island slowly revealed to me, the word "shape" took on a new meaning for me. It was at that point that I began to realize, in art, shape is everything.

As I walked down to the lake, there was so little light that all of the shapes around me had dissolved into one dark, mysterious shape. Slowly, as the light of daybreak rose, the far shore became a black bar across the horizon. Soon after that, a small reflection on the water separated the land from the water. As you can see from my drawing, there were no details in this black shape, but you get a pretty good idea of what we are seeing, simply by studying the edges of this horizontal form. But there is a surprise coming.

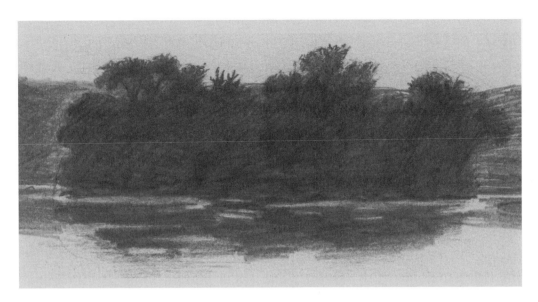

As the light in the sky grew stronger, another shape began to emerge from the main mass. Surprise! It's an island. If you look back at the first illustration, you can see by the edges of the horizontal shape that the outlines of the island were there all along; they were simply absorbed into the main shape. The background shape was now slightly lighter, and the foreground island appeared. There even seemed to be a slight halo around its edges, which, in my drawing, helps differentiate it from the background. However, details were still not visible, and both shapes looked basically flat.

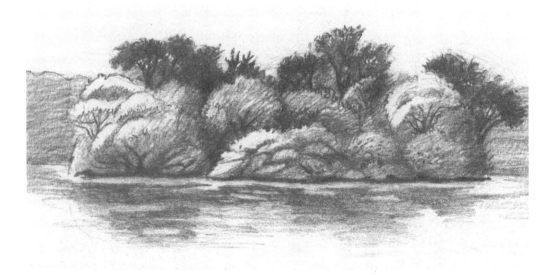

Finally, as the sun climbed overhead, all the details of the little island slowly emerged, and the light began sculpting the forms of individual trees. The background still appeared flat because of the mist coming up from the water. Notice here that even though the shape of the island is broken up by the smaller shapes of trees and bushes, it still holds together as a single shape. Later, when the early-morning mist cleared and the details of the background were easy to see, the picture became slightly more complicated—but even then, the island still presented itself as a single shape. The slight atmospheric difference and the slightly smaller size of the details in the background helped separate the shape of the island from the background.

Seeing the Shape

My story about the island shows how shape is the most basic element of art. Nature reveals details gradually, and changes in light make form and detail appear or disappear. Shape is dominant.

Think about these ideas:

- **You cannot draw a form, because you are drawing on a flat surface. You can only suggest a form.**
- **You cannot focus on both the form and the shape of an object simultaneously.**
- **You cannot focus on any specific detail on an object and the shape of the object at the same time.**

In fact, you cannot focus on the shape of a solid object at all, because its edges are at different distances from your eyes. If you force yourself to look at one edge of an object, the other edges blur. You see the whole shape of an object by focusing on its center and then spreading your vision to take in the entire shape. Nothing is in clear focus, yet the shape registers in your mind as a whole. The minute you focus on any detail, you lose sight of the whole, and it instantly becomes difficult, if not impossible, to draw without distortion.

Your brain creates a conflict whenever you try to consider the form and the shape of an object at the same time. The form will win every time.

Yet you must learn to see the shape. It's much easier to draw when you are thinking flat anyway. Then put the form into that shape—just like nature does. When the shape is right, it becomes easier to add the form. And when the shape is right, the viewer will help you by trying to see the form. Separate shape from form, and get control of both. This is the secret to successful drawing.

If you understand the basic idea of how the brain works—the right side is visual, the left side is logical (see "The Brain" on the opposite page)—you will understand why shape and form seem so interwoven, and why you need to force yourself to see shape first, then form. Look at the cylinder below. Viewed from the end, it looks like a plain circle. But you would never see an artist draw the end of a cylinder like this, even though it is perfectly accurate. Here's the reason: The "logical" half of the brain won't accept this; it needs more clues. So the second view gives a clue—that little crescent shape above the circle. That crescent begins to explain to the viewer that there is something more than a simple circle there.

Viewers might now accept the shape as cylindrical, but untrained artists have a problem drawing it that way, because their logical brains tell them that the cylinder is longer than this shows. This becomes more apparent as you drawing foreshortened arms or legs on figures, or drawings in perspective of buildings or other rectangular subjects, where we tend to draw much more than we can actually see of the foreshortened sides.

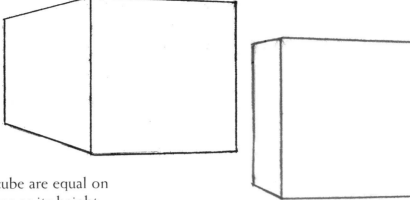

These cubes illustrate the problems that arise from the conflict within our brains when we draw three-dimensional forms. Since the dimensions of a cube are equal on all sides, its depth is the same as its height and width, and should appear that way in a drawing. The top cube shows how an untrained artist tends to draw a cube. Since your brain knows that the sides are all equal, it will try to make them that way in actual surface measurement. By comparing the shapes rather than the forms of the two sides, you will instantly recognize the one that shows the depth as a long thin shape—too deep to be a cube.

The hand with the pointing finger—I WANT YOU!—is an artist's nightmare. Fingers are supposed to be long and cylindrical, not round. Arms are also long, and it is difficult to convince your brain that they can take on the shape they do here.

These are but two examples of the problems that arise when you transpose solid forms onto a flat sheet of paper. They appear in more subtle ways when drawing figures and animals, and often you cannot see them as you are concentrating on your subject. You know something is wrong, but you don't know what it is. Seeing and getting the shapes right early in the drawing process completely alleviates the problem.

Another problem arises when we start detailing a subject before we get the big shapes drawn in correctly.

Here's the solution: You simply need to concentrate on the flat aspect by squinting your eyes while you are studying your subject. Squint down until the details are absorbed in the main shape (remember the island?), and look for the flat pattern. Closing one eye sometimes helps. By doing this, you are inviting the right side of your brain to tell you what the subject actually looks like, not what you think it looks like. In time, this gets easier, and eventually it will become a habit. Then drawing becomes a real pleasure, not hard work.

The Brain

Let's take a look at how your mind works during the act of drawing or painting. This subject is vital to anyone who is serious about learning to draw, and I strongly recommend Betty Edwards's books on right-brain drawing. What follows is my own interpretation of her important work.

When you begin to draw any object or scene, you are transposing a three-dimensional object to a two-dimensional surface. Drawing will be infinitely easier if you acquire the ability to see your subject as a flattened shape. Doing this will help eliminate the strange, out-of-proportion look of most beginners' work.

Your brain is divided into two halves. Each has specific functions. The left half is the scientist. It processes information with hard facts, numbers, and words. The right half is the artist. It sees things spatially and visually. The halves are designed to work together, and they do if you don't think too hard while you draw. But the minute you start to concentrate on little details, the left side of the brain is summoned. The result is that the halves are often at odds with each other, creating confusion. Train yourself to let your right brain dominate as you draw.

The Artist's Vision

Your eyes were designed to see objects in three dimensions. Because you have two eyes, your brain receives two slightly separated views, which it processes to produce the depth as well as the height and width of objects. When you close one eye, you still can tell that objects are three dimensional, but the sense of depth lessens.

Your brain is constantly searching out the form of objects, and it is a struggle to block out the "form" of a solid object in order to see its "shape." You are trying to make a three-dimensional object flat, but your brain knows better, and it will try to show you the error of your ways.

It takes a special effort for most of us to ignore the volume and see the actual shape of a three-dimensional object. This is the artist's vision. The few who are gifted with this ability tend to see in patterns and shapes easily. Drawing comes more easily for them.

We can all learn to see things this way to a certain degree, and it is absolutely essential that you master this skill if you are ever to learn to draw well. Do not expect a dramatic shift into a visual world of flat patterns. But, with practice, you will gradually begin to sense the shapes and the patterns things make with their neighboring shapes.

Try squinting. Squinting makes it more difficult to see the clues that make an object look solid, and so shapes are emphasized. Or try staring dreamily at the object until the pattern aspect begins to show itself. My favorite technique is to concentrate on the shape without focusing on any specific detail.

Look at the picture on the facing page. The first photograph, picture A, at the upper left, offers an opportunity to study the way nature controls shapes with light. Note the dark, almost flat silhouette of the background figure in the shadows. Now look at the figure in the sunlight; you see much more detail. Even though the main figure can be broken up into many shapes and patterns, one simple overall shape still dominates.

Cover picture B and relax as you squint your eyes to look at the first picture. Look for the bigger shapes and block out insignificant details. In your mind, you should get something like the blurred picture that you are covering. Uncover it to check how you did.

This difference would be more dramatic if you were looking at the actual scene. When you squint at picture A, the shadows darken enough to blend into the dark background. But in the actual lighted scene, they would hold their relationship with the light areas as they do in the blurred picture.

An Exercise

When you are trying to see shapes, first look for the big, simple, overall shapes. Then look for the shapes of shadows, lights, or any of the other details as you draw.

Try this experiment. Draw the figures from picture A, then draw them again from pictures C and D. Cover all the other pictures as you draw first from the original picture, then from the third picture, then from the fourth. Do not think of the people as figures; draw them as shapes. When you are done with the last drawing, uncover the first picture and finish your pictures by working from it.

This is still not the same as working from life because the photograph really is flat, and you do not have to translate the image in your head from three dimensions to two. But this exercise shows why reducing objects down to their simplest shapes, without clouding your mind with details, is a great way to see and to draw.

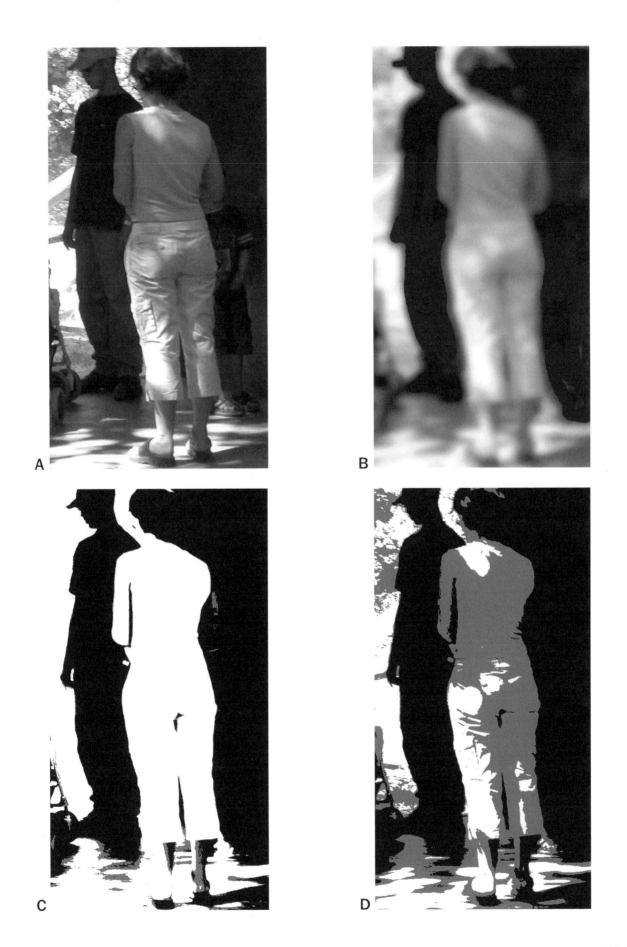

A

B

C

D

Materials to Start With

To begin any study of drawing, you will need a few materials to start with.

There are dozens of art supplies available today. But to keep things simple, I am limiting your choices to two time-tested, classical drawing media so that we don't get all wrapped up in problems of technique. If you learn these two, it will be fairly simple to pick up any of the other ones and learn them, or at least to make a determination whether you like them or not.

For learning the things in this book, you will be using simple graphite and charcoal in both pencil and stick form. The best way to learn to use them is by actually playing around with them. But here are some facts that will be helpful to you.

Both graphite and charcoal come in solid sticks and in regular pencil form. Each comes in varying degrees of hardness or softness. Graphite is available in a wide range, from 6H (hardest) to 9B (softest). For our purposes, you can forget about the H values and work mostly with a B value or softer. I recommend starting out with a B, a 2B, a 4B, and a 9B. You can add to this selection or replace it as you gain experience.

The graphite sticks are available in approximately the same range. A 2B will be adequate for starting out.

Charcoal (or carbon) pencils are graded the same, with the H values being the hardest and the B values the softest. But it seems to me that the manufacturing of charcoal pencils must be harder to control than graphite pencils, because the density is never consistent, and some of them have little hard spots in them that make them aggravating to work with. Those charcoal pencils are just duds, and I usually throw the whole pencil out when I find a hard spot; it always seems to continue all through the thing, and you can waste more time sharpening the spot out than it's worth. Charcoal sticks are better quality; at least, the compressed variety seems to be more consistent. Get some of the softer grades of both to start.

For paper to work on, get an eighteen-by-twenty-four-inch newsprint pad for your bigger experiments and a small, inexpensive sketch pad that you can carry with you easily. (There's more information on using your sketchbook in Chapter 4.) You can experiment with as many different, more expensive papers as you like later. Eventually you will find those that suit you best, but for now, stick with the inexpensive stuff so you will feel free to experiment and try new ideas.

Even if you are a fairly experienced artist, try going back to these basic materials. If you are stuck in a rut, then maybe you are using materials that do not suit you. We all have a tendency to expect more out of our drawing mediums than they can give, and, as a consequence, sometimes we are disappointed with the results we get. Try starting fresh in terms of materials and the techniques in this book, and see if your work develops in a new and positive direction.

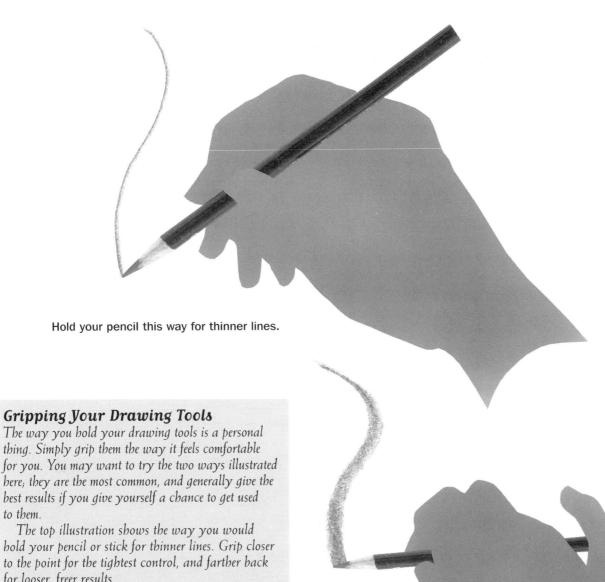

Hold your pencil this way for thinner lines.

Gripping Your Drawing Tools

The way you hold your drawing tools is a personal thing. Simply grip them the way it feels comfortable for you. You may want to try the two ways illustrated here; they are the most common, and generally give the best results if you give yourself a chance to get used to them.

The top illustration shows the way you would hold your pencil or stick for thinner lines. Grip closer to the point for the tightest control, and farther back for looser, freer results.

The bottom illustration shows how to hold a pencil or stick when you are putting in a broader tone. I use this grip for both line and tonal work. When putting in lines with a stick of graphite or charcoal, I simply hold the stick at a sharper angle to the paper. This grip gives me the best control, and the freest results. For very small, tight work, I use the first grip.

Regardless of the grip you choose, remember always to look at your drawing straight on while you work. This is a vital habit; it makes your line of sight perpendicular to the work. If you don't look straight at your drawing, you risk creating all kinds of distortion. If you forget to do this (as all of us do at one time or another), then you will find that your drawings seem mysteriously skewed when you look at them later!

Use this grip
for flatter tones.

Understanding Your Materials

Understanding the limitations of your materials will keep you from constantly attempting to push them beyond their limits, and as a result, becoming unhappy with the results.

Here are two value charts. Working with your large sketch pad and your basic drawing tools, try matching these charts with both charcoal and graphite pencils. You will quickly see that the graphite cannot give you a real rich black, but can make up for it by giving you slightly better control in the upper value ranges, the lightest values. You will want the higher numbers (6B to 9B) for the darkest values. When you work in the lighter values, the lower B numbers will work better.

Experienced pencil draftspeople can get good results using one pencil, often an HB, although many use the full range of available pencils. If you needed good control in the very lightest values, you would want to use the harder H range, and you would work on a harder, smoother-surfaced paper. For now, though, concentrate on developing your light touch with inexpensive paper and soft pencils.

At this point, you should be discovering that, in both charcoal and graphite, it is very difficult to get more than nine values that can be distinguished from one another reasonably well. These values are represented in the larger value chart here. You will also notice that graphite gives a rather unpleasant shine in the blackest values. So if you need really strong blacks in your drawing, charcoal is a better choice. Graphite, with its shiny quality, offers a smaller range of values than charcoal.

Compare the two value charts. The one with only five values is easier to "read" because the separation of the values is clearer. These tones are like tones in a musical chord. When notes are too similar, too close together, the result is soft, mushy, characterless. When the notes or tones are distinctive and different, they produce a clear, stronger result. Try to create similarly crisp effects in your drawings.

Try matching these charts using your favorite drawing materials. The five-value chart is much easier to create—and five values are sufficient for most sketching.

An Exercise

In order to get control of your values, you need to develop a sensitivity to your hand pressure as you work. "Feeling" this is easier than it seems, because you can see your work and adjust your pressure as you go along. If you know beforehand how dark your line should be, you can try different ways to simply get it the way you want it.

A good way to get the feel of this is to hold your pencil or stick broadside to your paper and make squiggles. Start with the darkest tone you can get, and go to the lightest tone you can actually see on your paper.

Work in both pencil and charcoal, and notice the difference between them when you finish. The top illustration was made in pencil and the bottom one in charcoal. Although you can see some of the difference here, the values will be much more apparent in your drawing—printing inks can't capture the subtleties between the two mediums.

As you practice, concentrate on the top three lightest values in your scale. Start with the lightest value that you can see on your paper, then work on the next closest value that can be distinguished from the first, then on the next lightest. Control of these lighter values is vital, especially if you intend to draw the human figure at some point in the future.

Start with the darkest tone you can get, and go to the lightest tone you can see.

Controlling Values

Now that you understand the distinctions between tones and have begun to work on controlling your values, try experimenting with graded tones. One of the better ways to model with tones is to use crosshatched lines. To crosshatch, just keep running parallel lines over one another at crossing angles to get the tones the way you want them. Create shaded areas that move from light to dark, as shown here. This technique requires a little practice, but it is a good way to get softer modeling and blended tones. The texture can be softened by smudging the lines lightly with your finger.

The first drawing here was made with the point of a graphite pencil. Note that the lines were made by simply squiggling the pencil back and forth without lifting it. This is a fast, simple way of blending values and keeping things loose and free. Some artists make almost perfectly parallel lines, like the old

steel engravings. Don't try that at this point; just keep your work loose until you get enough control to try more complicated approaches.

This second illustration was made with charcoal—notice that the dark values are much darker than I could achieve with the graphite pencil. I used a blunt point here, but I could have made a similar drawing with the side of a stick if I wanted to get broader tones. Try it yourself.

Remember, the most difficult tones to control are the lighter ones, the top three tones in your value scale. It takes a light, practiced touch to get these tones right. Work on this range of tones until you can get a very slight but noticeable difference between them. Start with the lightest tone you can make with the pencil or stick that you are using, then work into slightly darker tones.

An Exercise

This exercise in hand control will be famil-
iar to those who have read my first book,
Figure Drawing Workshop. It has proven to be
such a valuable way to develop the right
kind of control that I am repeating it here.

To practice your hand control—which
is helpful as you work on achieving line
control—you simply put a half dozen or
more dots randomly on a fairly big sheet
of paper. Then pull long lines down from
various distances to hit the dots. Keep the
lines flowing smoothly, and try to hit the
dot dead on.

Make the lines using a variety of grips,
some with the broad side and some with the
point of your pencil, held both close and far-
ther from the point. Make some straight, some
smoothly curved. Work at a speed that allows
you full control over your lines, but try to push
your speed a little as you practice.

When you do this exercise, you must be
conscious of the dot as you make your line.
This helps you develop the proper way of
working, by being conscious of your whole
drawing at the same time you make a mark on
the paper. It is also a great way to become
familiar with and get control of your tools.

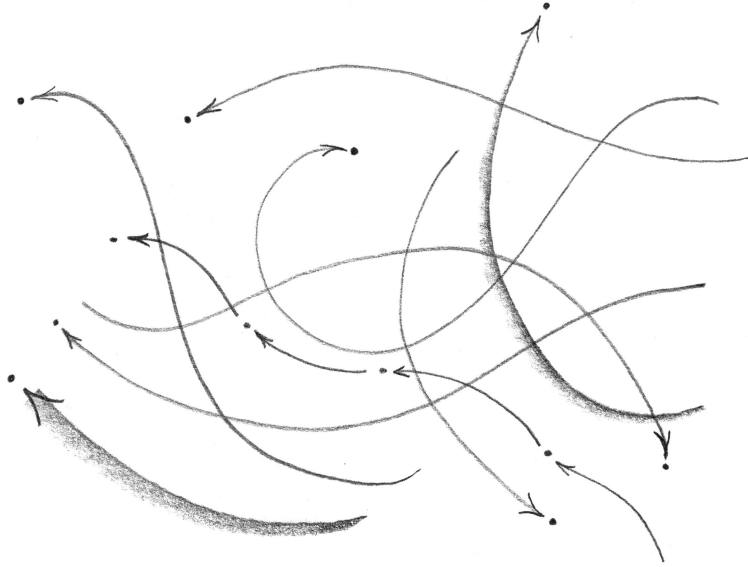

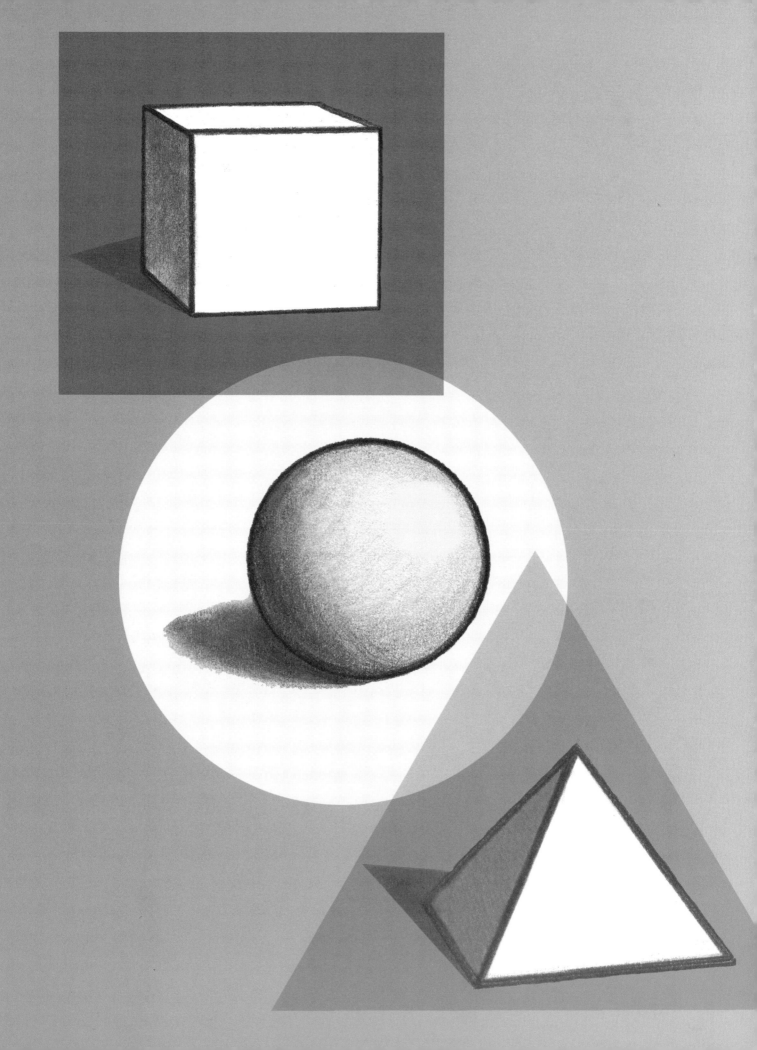

2 Shape Basics

In drawing, all objects can be broken down into their most basic shapes. This chapter will teach you how to use simple geometric shapes as well as more complex organic shapes to capture the world around you in your sketchbook and your larger drawings.

The World of Shapes

The visual world is made up of shapes. These shapes have differing colors, values, textures, and edges. These differences are what make shapes visible to you as they come together in your field of vision. Shapes can be broken down into two general categories, geometric and organic.

Learn to see the shapes within the shapes.

Although there are occasional examples of geometric shapes in nature—for example, the cells in a honeycomb—for our purposes all the geometric shapes are the products of humans with their rulers, compasses, and other instruments. These shapes include circles, ellipses, squares, triangles, and all of the other polygons. Most human-made objects can be visualized by starting with basic geometric shapes.

Organic shapes, the random, free-form shapes of the natural world, are the shapes that we are most interested in here. All living things are organic in shape, and so are stones, rocks, and clouds.

Is there any way to relate these two types of shapes? Of course there is! In this chapter, a key exercise asks you to practice drawing circles, squares, rectangles, triangles, and other geometric shapes. Whenever you look at an organic shape, assess it for how it relates to a geometric shape. On this spread, for example, I have drawn and then scanned silhouettes of birds of prey to help demonstrate this idea.

First, think about geometric shapes. The square is the basic workhorse for the artist. If you learn to draw and visualize a square (and that's easy to do), you have the basis for analyzing and drawing most other shapes, including organic shapes. Having a good mental image of a square (and a good ability to draw one) is almost like having a ruler in your head.

Simply imagine a square with vertical sides around, or inside of, the irregular shape you want to draw, and then you have a much clearer concept of the complex shape. This technique even gives you the orientation of the shape.

The circle and its three-dimensional relative, the sphere, are unique in that all of their edges are at exactly the same distance from their centers. The sphere is the only form that has exactly the same shape when viewed from any angle.

Many organic shapes are more or less triangular in shape: trees, mountains and hills, cliffs. Others are more or less rectangular: boulders, tree stumps, bushes.

Take a look at our bird on this page. I have surrounded it with a square. Notice how this makes it easy to see that the bird's

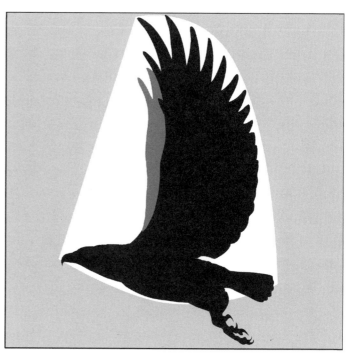

The square is the artist's best friend among geometric shapes. Every shape, organic and geometric, can be related to a square. This silhouetted bird in flight shows how using a square makes it easier to see the overall shape of the bird—a rough triangle.

"height," from the bottom of its feet to the tip of its wing, is longer than its length, from the tip of its beak to the end of its tail. Suddenly it becomes clear that this bird in flight is roughly triangular. Now won't it be easier to draw this bird?

Look at the birds on this page. Seeing them as negative and positive shapes makes it clear that the body of the bird can be related to an elongated oval. The wing is almost a semicircle, with feathers added. The beak is a triangle. The tail is a triangle, too.

Organic shapes are the most difficult to analyze and draw accurately. Fortunately, many of them can be captured by exaggeration; pictures of these things do not need to be precise in the purest sense of the word. There often is a certain amount of leeway in interpreting an expressive organic shape. A good artist senses the life in these shapes and can capture it without resorting to measuring or other artificial methods, but it takes a great deal of practice to develop this ability. For now, try to draw these shapes exactly as they look to you. But learn to see the shapes within the shapes first.

Look at these two birds. Do you see how each body is an elongated oval? What shape is the wing? How about the beak? What shape would you start with if you wanted to show two birds flying close together like this?

Geometric Shapes

Most human-made objects are based on simple geometric shapes. These shapes can be broken down into relatives of three basic families: the circle, the square, and the equilateral triangle. It is fairly easy to learn to draw these two-dimensional shapes freely and accurately.

Their relatives, ellipses, rectangles, and triangles with unequal sides and angles, are somewhat more difficult, but still within the reach of most of us. Of course there are many modifications of all of these.

When considering these three basic geometric shapes in three dimensions, the circle becomes a sphere, or ball; the square becomes a cube; and the triangle, a three-sided pyramid. There are additional three-dimensional geometric shapes as well: the ellipsoid (an elongated sphere), the column or cylinder, the cone, and the four-sided pyramid. These are mostly combinations of the basic shapes and are still strongly related to the three basic shapes.

The edges of solid shapes are affected by the laws of perspective. Later in the book, I will give you a short introduction to perspective. However, my focus in this book is on using shapes in the freehand mode based on the flat silhouette, the shape of objects. It is better not to get all wrapped up in perspective until you have a clear grasp of simple shape drawing. For now, all you need to think about is that things get smaller as they get farther away from you, and they are in front of another object if they overlap it. Use your eyes to compare sizes as you draw, and study perspective only when you feel the need.

If you train yourself to comfortably draw the circle, square, and equilateral triangle and their three-dimensional counterparts freely, and with reasonable accuracy, the other geometric shapes can be handled as well without much special consideration. It's the natural organic shapes, including figures, animals, and birds, that require a great deal of attention, and they will be our main interest.

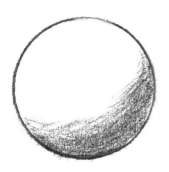

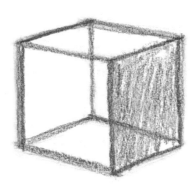

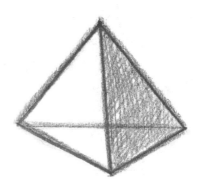

An Exercise

Practice drawing two-dimensional geometric shapes and their three-dimensional counterparts. Fill up many sheets of paper with freely sketched basic geometric shapes of all sizes. Stick to squares and cubes in the rectangle family, and to equal-sided triangles and pyramids in the triangle family; they require more concentration than rectangular or unequal-sided triangular figures. Decide the size of these objects before you start to draw them. When sketching shapes in the circle and ellipse family, swing your pencil very lightly over your paper in a circular fashion until you feel comfortable with what you have started to draw, and then bear down. Similarly, when sketching shapes in the square or triangle family, make light shapes (not just lines) until you feel you have good basic shapes, then press harder.

This exercise forces you to see the whole shape as you are drawing it, rather than just the particular line you are making at the time. Do not get discouraged if your drawings are not satisfactory at first. You will see noticeable progress in a very short time if you persist. Don't expect perfection—there really is little point in perfection! Just keep your work loose and free, and do the best you can; but do it often.

These shapes are the basis for everything you will ever draw, and when you get them under control, you will have little trouble moving on to more complex subjects.

Human-made objects are simple modifications of these basic shapes. Look for them as you draw buildings, bottles, steeples, furniture, automobiles, and practically anything else. You simply need to decide the proportions of the basic shape that represents your subject, draw the shape, and modify it to match the model.

Understanding Organic Shapes

The world of nature is made up of organic shapes and forms. Rocks, animals, birds, people, trees, clouds—any shape that is not geometric can be considered organic.

These shapes are the focus of this book. After learning the basic geometric shapes, you can adapt them to draw buildings, boxes, cityscapes, barrels, wagons, automobiles—almost anything made by humans. But the organic shapes are endless. Every living thing has its own unique organic shape.

How do you draw all of these wildly different shapes? Exactly as you see them. But you will need to practice for some time to see them. Organic shapes are the most difficult to capture. You will need to put in effort before you can loosen up and approach them more creatively. This practice time trains your eye to sort out the important factors of a shape.

There is no foolproof way to draw these shapes freehand. Instead of looking for photographic realism, draw freely, enjoy the process, and look for the big shapes that will bring your drawings as close as possible to your model. They will never be perfect. Fortunately, most organic shapes are not measurably precise like geometric shapes, so it is not necessary, or even desirable, to get an exact duplicate of most things you draw. But you must learn to recognize the spirit, the essence of a shape. This is something indefinable, and the only way to learn is by working to try and capture the exact shape and form.

Ask yourself some questions when drawing a shape: What are its proportions? Is it a wide shape or a tall one? How many of the shorter dimensions would go into the longer one? Where is the center point? Do any of its edges run vertically? At first, you can answer these questions by measuring—hold your pencil out at arm's length and use your thumb as a guide. But you can train yourself to estimate sizes and proportions by simply looking at your subject. Then check your calculations by measuring afterward.

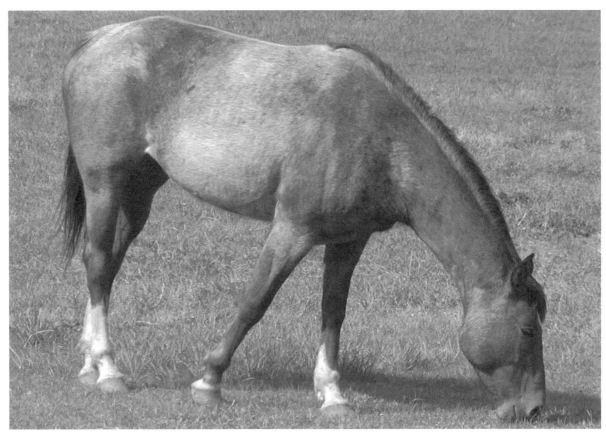

Sometimes a shape will have one edge that runs vertically, while its other edges run off at differing angles. When drawing this type of shape, put in that vertical first—it's easy to get a vertical correct—and then compare the other lines (the edges of your subject) to it. A horizontal line would work, too, but because of perspective considerations, the vertical is more dependable.

This first vertical line acts as a stabilizer, and even if your other lines are not exact, that first line will help hold the proper orientation of the shape. The shape you are drawing may not have any actual vertical edges, but it can still give the impression of being vertical.

When there is no actual vertical edge on a shape (or model), and if there is no vertical line near it to help you judge its direction, you can imagine one next to the model. Drawing this line will give you a point of reference, and then you can proceed from there. Once you are confident that this first line is accurate, you relate everything else to it as before.

I am going to offer you a tool to train your shape perception that is so simple and so effective, it seems amazing to me that I have never seen anyone use it before. But first, we have another experiment to try.

An Exercise

Draw the shape of the horse on the facing page in outline as accurately as you can on a sheet of tracing paper. Do it approximately like mine below, except try to get it the same size as the photograph. Cover my drawing and stand the book up at a little distance from you as you work. Keep your drawing light and free, and don't put in any details; just try to get the shape accurate. Remember to ask yourself the critical questions about size and proportion, and to judge these measurements just as you would if you had a live animal to draw from.

Notice that for my drawing I used the broad, flat side of my pencil to make a rather thick line. This wide line gives me some leeway to place my next, more accurate lines.

When you finish your drawing, lay the tracing paper over the photograph and see where you went wrong in your calculations. Do you tend to overestimate? Underestimate? Are proportions difficult for you? Try this exercise with other simple photographs. It will teach you a lot about your own drawing habits.

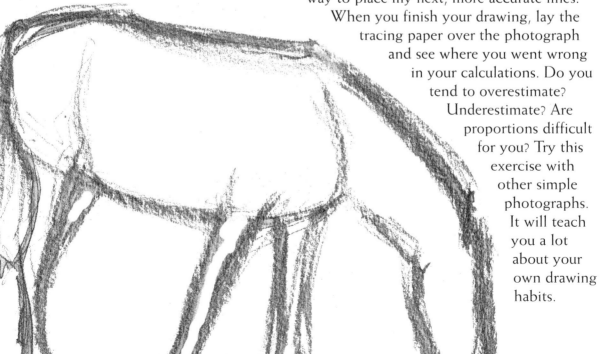

The All-Important Silhouette

Whether you are drawing human-made or organic objects, the shapes, or silhouettes, of objects are their most important visual property. The silhouette can convey a great deal of information about an object. But silhouettes can also be misleading. Consider the figure on this page.

What is it? You could mistake it for any number of things. Is it a simple hexagon? Is it a cube viewed from above? Is it a cube viewed from below? Maybe it is an open box. As you can see, this figure is not the best choice of a viewpoint to depict any of the other things shown around it. (Figure B is a little better, because it seems to offer fewer possibilities to mistake it for other things.)

Look at the most basic outline of an object—and think about how you can put the three-dimensional object into that silhouette.

It often requires the addition of "clues" to clarify shapes. These clues could take the form of additional shapes nearby to help identify the first shape, but usually clues take the form of smaller shapes, lines, or textures inside of the contour of the shape.

Look at the cubes shown on these pages. To show cubes, I simply added a couple of lines to the basic shape, and those lines did the trick: The shape became a form. But in the open box, I added tones to the lines for additional reinforcement.

You can carry these clues to such a degree as to make it extremely difficult to think of the object as a flat shape. We will look at that idea more in Chapter 3, "Adding the Third Dimension."

From this little example, it should be apparent that the viewpoint, the angle at which you choose to show your subject, is a very important consideration. Always look for the angle that gives the clearest and most interesting information to the silhouette, or basic outline shape.

In figure-drawing classes in art school, the students are often arranged in a circle around the model. Only a few of them will get a good silhouette, or overall shape, to work from. They are the ones who stand a chance of getting good drawings. The other students have little hope of getting more than a mediocre drawing, no matter how well they draw.

Even in situations where the lighting is so strong that it seems to break up the subject, you need to be very conscious of the silhouette and find ways to keep the form from becoming fragmented. Remember, shape is everything.

In your day-to-day life, watch for examples like the hexagon. Learn to recognize how the silhouette might be deceiving, and think about details that can be added to a silhouette to make it obvious what the silhouette is showing. Focus on adding the fewest details possible to make the outline recognizable.

The ability to see and understand the power of the silhouette will give you much more creative control over your work. You will be able to reshape objects and organize them in ways that are not available to those who are bound by conventional ways of seeing. No subject will pay you more dividends for the effort you put into it.

What Does This Shape Represent?

A cube viewed from above?
A cube viewed from below?
Maybe an open box?

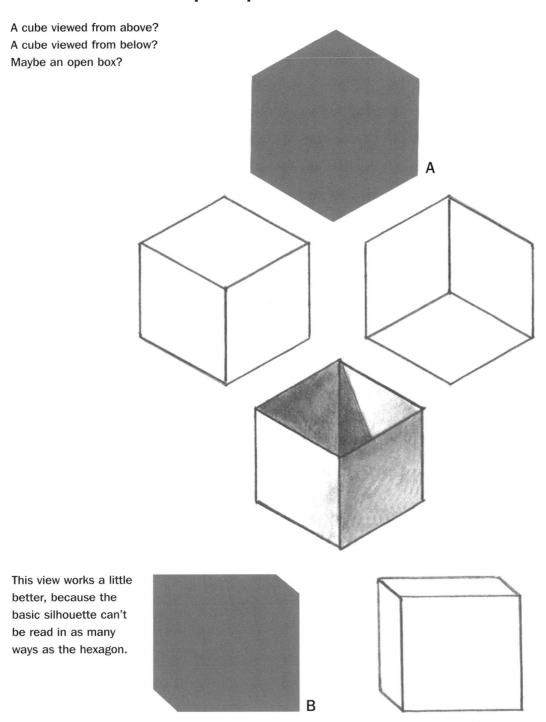

A

This view works a little
better, because the
basic silhouette can't
be read in as many
ways as the hexagon.

B

Orientation

Every shape has an orientation: It is either vertically, horizontally, or diagonally oriented. The lines that form the edges of shapes also have their own separate orientation, but the overall shape takes on one of these three aspects.

Orientation means more than how the object is positioned.

If a shape is taller than it is wide, it is a vertical, or tall, shape.

If a shape is wider than it is tall, it is a horizontal, or wide, shape.

If a shape leans, it is a diagonal shape.

But there is more to orientation. It means more than simply how the shape is positioned. Different orientations give a shape a feeling. They imply a mood.

For example, vertically oriented shapes seem to be balanced, standing still, or static. Horizontally oriented shapes feel controlled, placid, settled.

Diagonal shapes give the feeling of movement, either movement that is happening as you look or movement that is about to happen.

As you look for silhouettes and overall shapes, take note of your subject's orientation. What mood does the orientation imply?

As you draw, bear some ideas in mind. First, notice that when you are drawing shapes that are oriented horizontally, you must consider the perspective aspects if the shape is to sit properly in the picture. Actually, this is true of all shapes, but the problem is magnified with long horizontal shapes, which can seem to float off the page or above a horizon or obvious horizontal, such as a floor. I hesitate to even mention this because, if you really see the flat aspect of the shape, and draw it as you see it, this should not be a problem. But this is one of those rule-breaking situations where it can be beneficial to consider the three-dimensional aspect at an early stage.

When you draw vertical or diagonally oriented shapes, work carefully. Even a slight deviation from the vertical gives a feeling of impending action, and too much will throw the whole picture off balance. Are you drawing a runner? Are you drawing an alert cat? Does it look like one figure is looking at another—or like a vase is looking at a broom? Remember, you may not want to imply that an inanimate object is leaning toward another with apparent interest.

Look at these examples of both geometrical and organic shapes. In each pair, both silhouettes project the same impression of stability or impending action. Even when you are drawing abstract shapes, you need to be aware of the orientation of your drawings.

An Exercise

Select a subject that is fairly easy for you to draw—for example, a vase or a teapot. Practice getting the basic shape down on paper. Make several versions of your sketches. After you have made a few drawings of the same object, try changing the orientation. Notice how the slightest change in orientation—without altering the basic shape of the teapot—can change the feeling of your drawings.

Vertical Orientation

This orientation has a feeling of balance. It is comfortable. This object just might stay put for a while. Note the oval and the rectangular shape surrounding the cat shape. Although they are simple geometric shapes, they have the same sense of stability that the more recognizable cat does.

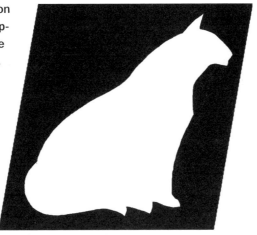

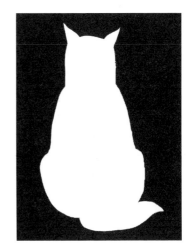

Diagonal Orientation

This shape gives the impression that something is about to happen. It is leaning slightly in the direction in which it will move.

Horizontal Orientation

This shape is totally at rest. It projects a feeling of calm, even serenity.

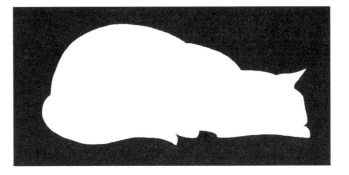

Reference Points

Now you have been drawing geometric shapes, such as squares, and you have started drawing organic shapes, such as horses. Here is a technique that brings the two types of shapes together. It shows you how using squares to create reference points will help you draw any shape in the world.

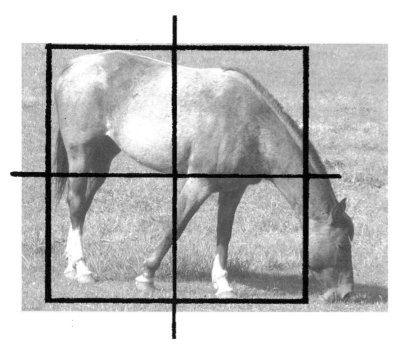

Most of this horse fits within this simple grid. When it's time to draw the head, use the lines to help you position it and size it relative to the body.

Here is the horse you were drawing earlier. Remember how hard it was to capture the shape of the horse the first time?

This time, draw a light square the size of the one shown here, and divide it into four smaller squares on your paper. Draw the horse again from this picture. Fit it to your square exactly the way you see it here. Once again, keep your horse drawing simple, and just try to relate the shapes to the squares accurately.

Did you notice how much easier, and more accurate, your new attempt was? This is my magic grid. It gives you enough informa-tion about shapes to draw them easily and accurately every time. That simple grid will tell you everything you need to get your shapes as accurate as you care to make them.

If you use this concept properly, it will teach you how to look at shapes, and it will help you develop a perceptive eye so you can work freehand without it.

Starting now, I want you to get serious about squares. Although you have practiced with geometric shapes, it is time to focus on squares. Concentrate on them until you can draw them accurately every time. Draw first, then check by measuring later.

At the same time, you should be trying to visually form a box around things as you look at them. Obviously, most things will not fit properly in a square, and they will overlap in places just as our horse does. Sometimes objects are proportioned in a way that requires two or even more squares for their long dimension. But as you look at your sub-ject, try to imagine a square with vertical sides in some relation to the object. (For more on using grids, see pages 140–141.)

The Magic Grid

As you now know, shapes are easier to draw when you relate them to a square. So here is a little device to help you use this infor-mation. I call it a magic grid, or a shape ruler. Consider it a training aid, and let it help you learn how to see shapes.

First, make your own magic grid: Take a piece of clear acetate and trace the two-inch-square on the facing page on it with a strong black permanent marker (if the lines are smeary, seal them with another sheet of acetate or spray-on clear sealant). Carry this grid with you when you go out to draw.

Hold up the sheet in front of you, and view your subject through it. Move the grid closer to your eye, or farther away to frame

Shapes, especially organic shapes, are easier to draw when you have firm reference points such as this square grid.

your entire subject or any part of it. If you get the grid too close to your eyes, the lines will blur. Be sure you hold the grid straight out in front of your face, and keep the side lines vertical.

Position the center of the grid over a clear, defined shape. Then use the lines to judge angles on the contours of shapes. Lengths and sizes are easy to compare because the squares are identical. It's simply a matter of moving the acetate farther or closer to your eye to properly frame the shape or section that you are studying.

At first, you could even draw the square figure on your paper to get your basic shape right, and then compare the shapes on your model to the ones you have drawn. You can also check your drawing against the model by viewing the drawing through the grid.

The best way to use the magic grid is to try to judge, and sketch in things by eye first, and then check the results for accuracy with the grid. Once you get your subject roughly blocked in, use your eyes alone to tell you how to fine-tune your drawing.

Make a magic grid for yourself, and play around with it. You will soon find many ways to use it, and you will be amazed at its practicality. It will help train your artist's vision as you begin to see shapes more and more clearly. A magic grid is a great tool—but there is no substitute for strong observational skills.

Every object you want to draw offers several options for placement of the grid. Look for a shape and use the magic grid to help define that shape. The squares of the grid let you relate organic shapes to geometric shapes.

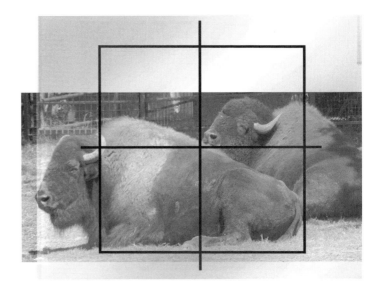

Flattening Curves

All shapes are surrounded by either straight or curved contours that can be approximated by lines. A circle is an example of a perfectly symmetrical curve. If you attempted to plot a circle with straight segments, you could start with a square and continue breaking it up into pentagons, hexagons, octagons, and all of the other geometric, equal-sided shapes, until you wound up with a circle.

Curves have a definite character. Most curves are made up of unequal segments that run for a distance on one radius before they turn to curve on another radius. It can be extremely difficult to draw these curves accurately. However, each segment can be visually flattened into straighter lines to make it easier to capture the curve, as well as the overall shape of the object you are drawing. Train yourself to draw this way, and you will be surprised to see how much easier it becomes to break curves down into their "straight" pieces and then, consequently, draw them. You will find it much easier to draw any organic shape when you straighten your lines as you lay it in.

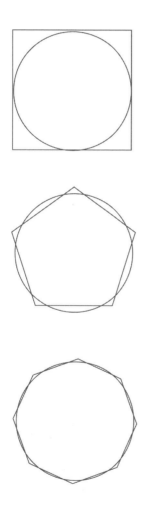

Every curve, organic or geometric, can be broken down into a series of lines. A circle can be drawn by starting with a square and then adding more and more straight lines until the square becomes a circle.

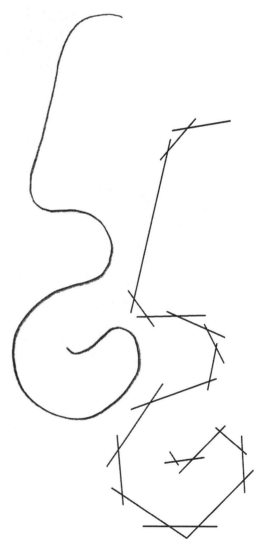

Even this complicated curve can be flattened into manageable lines, then re-created.

The illustrations shown here of our old friend the horse give an example of how this process works. The sketch in the middle shows how you would begin with the big simple shapes, getting the basic proportions and using lines to capture the directions of the curves. You would sketch very lightly at first. The second sketch shows how you would then develop your drawing by breaking the big segments into smaller ones, still working lightly. For a finished drawing, you would then draw in your flowing curves more strongly, with confidence that they capture the character of the model.

Try working with straight lines for a while. You'll find that you can see proportions and directions much easier, and your drawings

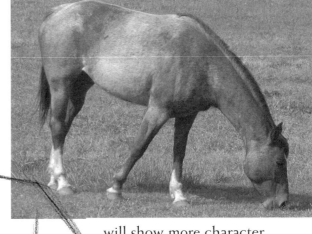

will show more character. Eventually, you will learn how to do this "flattening" over the whole surface of a form, not just the contours of the shape. The trick is to make sure your first big line is right. After that, you relate everything to it as you go along. Each time you add another line or shape it gets easier to see where the next one should go. Remember that you need to observe and compare the surrounding negative shapes as well as the actual shapes of the model while drawing.

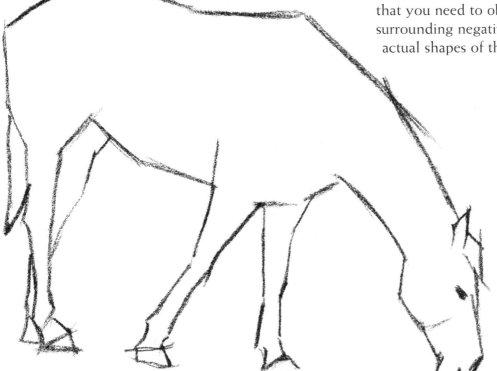

When sketching, use lightly drawn straight lines to get the basic proportions and directions of curves on your subject. Then refine the curves by drawing finer and finer lines. Eventually you can refine your picture to make the curves smooth and flowing.

Understanding Shapes

Let's review the important facts about shape basics before we learn how to turn these shapes into three-dimensional forms. The three basic geometric shapes are the circle, the square, and the triangle. These three shapes are fairly easy to recognize, visualize, and draw. It is vital that you learn to do this before you go any further.

Look at the diagram on the facing page. Notice how I have enclosed a triangle within a circle, a circle within a square. Everything is inside the square. Learn to understand the relationships between the three main geometric shapes; this will help you capture even the most complex organic shapes.

Use squares and rectangles to set up a series of reference points that will help you as you draw.

Of the three, the square—and its cousin, the rectangle—are the most important to you because just about any shape that you will draw can be enclosed in one or the other of them. Once you have determined the size of the square or the proportions of the rectangle, you have begun to set up a series of reference points that will help you immensely as you draw the shape.

You can do this either actually or mentally. Since the edges of this square or rectangle are always vertical and horizontal (just like the edges of your drawing paper), you have an immediate guide as to the orientation of the shape and its various edges. (We will cover this more thoroughly later when I explain the use of the grid.)

The little figure at the bottom of the facing page is a fairly complex organic shape. Enclosing this shape in a rectangle makes it much easier to draw accurately than if it were without such an enclosure. Suddenly you can see that the overall shape is closest to a rectangle. The legs form a triangle; the body is a rectangle, too. The proportions are easier to see as well.

Take a thoughtful look at this figure. It is nothing but a simple, flat organic shape, but look at the amount of information you can get from it. Of course you know exactly what it is, even in silhouette, because your brain fills in the missing information.

A carefully thought-out silhouette of anything—that is, a tracing or outline of its overall shape—will carry the bulk of information about it. If your first shape is properly worked out, you need very little additional detail in a drawing. Anything extra is gravy.

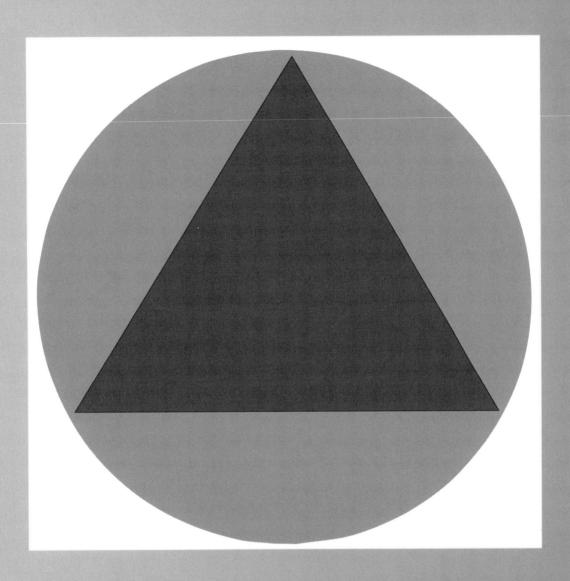

Any shape can be enclosed within a square or rectangle. Seeing a form as a flat silhouette makes it easier to grasp the shapes that are part of it.

3 Adding the Third Dimension

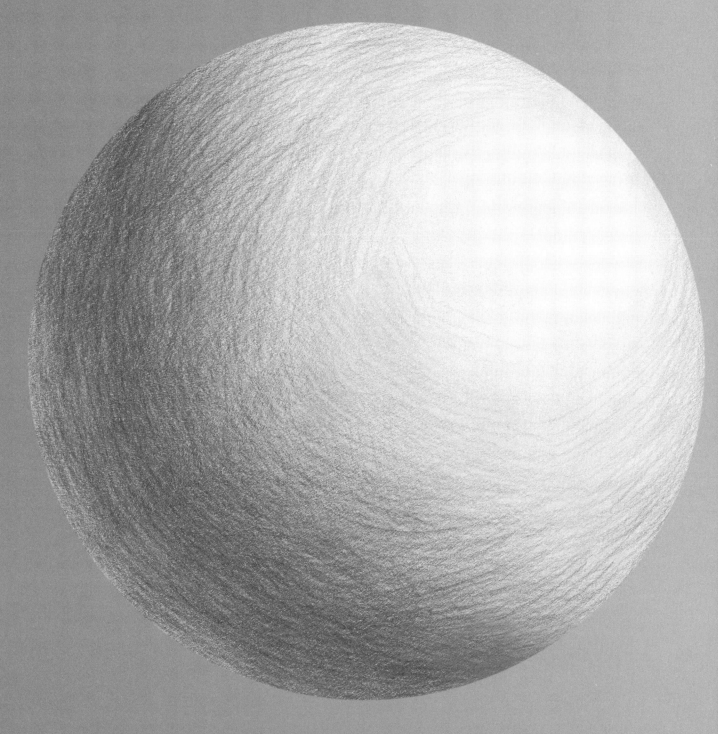

So far
we have focused on
flat shapes. Now it is time
to make our shapes into forms.
Think about light and learn to
use line and tone to create the
illusion of three dimensions
in your drawings.

Turning Shapes into Forms

While you were concentrating on the shapes or patterns as you drew, you may have noticed that you had to relax and "spread" your vision to take in the whole shape at one time. You were processing the image through the half of your brain that was designed to see that way.

When you begin to pay special attention to the solid, three-dimensional aspects of your subject, you need to call on both halves to do their jobs. Don't allow your "scientist" half to take over to the point that you lose the big overall picture. From here on in, you will need to back off from your drawing periodically to bring this big-shape picture back clearly into focus.

Once you have drawn a simple, basic, flat pattern roughly the way you want it, the drawing will begin to take on a solid quality on its own—even though you were thinking "flat" while you were drawing. You want to reinforce this solid, three-dimensional aspect as much as possible. How do you do this?

You can do it with pure line, or you can do it with tone (that is, with values). Using tone, there are two ways to show form: The first way is the sculptural way, and the second is the tonal approach, in which you duplicate the light on your subject.

Using the sculptural method, you use your sense of three dimensions to "sculpt" the form of an object.

The tonal approach is based on the idea that the white of your paper seems to come forward and dark areas seem to recede in proportion to their intensity. The lighter shades turn back slightly into the paper's surface, and the darker tones recede the deepest.

Since I have been urging you to see the basic shapes to start a drawing, you may be confused now that I am telling you to switch to thinking in three dimensions. Don't be confused! These ideas are not contradictory; they are complementary. They work together to give a more complete understanding of how things look.

By mentally separating these two visual aspects during your early training, you develop the habit of seeing the shapes more accurately. Eventually, they become a personal way of drawing that will give you much greater control. An accomplished artist unconsciously subordinates either shape or form according to his or her way of interpreting the subject. He or she shifts from concentrating on shapes to concentrating on solid forms without conscious thought many times during the process of a single drawing.

Ultimately, we are interested in drawing solid forms as convincingly as possible. The mechanics of seeing are pretty much the same in all of us. It is in the interpretation of what you see that makes drawing complicated—and expressive.

Many drawing teachers disagree with the idea of starting out thinking flat first. They talk about the "senses" and "feelings" as they relate to drawing, and they will get no argument from me. But, no matter how it's done, you are transposing forms into flat shapes when you draw; and if the shapes are wrong, no amount of feeling can save the drawing.

So look for the flat pattern when you are laying in a drawing or having problems with one, but be sensitive to the solid volume of your subject after the shape is right. This learning stage, where you consciously break every drawing into two separate stages of development, will not last forever. Eventually the two will come together without conscious thought on your part.

Creating Three Dimensions

This is a simple outline of a ball. It is really a flat circle, but because the viewer's brain wants to add the third dimension, the circle would be accepted as a ball if it were part of a picture that contained only outlined objects.

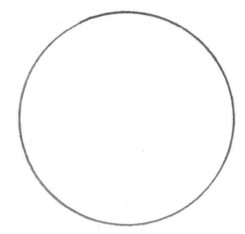

Tones add a feeling of solidity. To draw a ball like this, think of your eye as the source of light; the planes that face you will be the lightest. The surface gets progressively darker as the form goes away from you and seems to go deeper into the picture plane. Note that the tones get darker as they approach the edge, until they become a dark outline around the form. This sphere looks smoothly rounded because there are no sharp edges or textures between the tones as they lighten or darken.

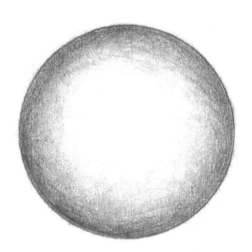

By "planes" I mean the general direction of segments of the surface. In a round ball, there are smooth transitions from one plane to another. (To better understand this, imagine that you were to cut slices off the edges of the ball, as if you were peeling a potato. This would give you a series of flat planes rather than the smoothly rounded surface you think of in a sphere.) The planes that face you would be the lightest. The planes get progressively darker as they recede from your line of sight. And they would have definite edges where they meet.

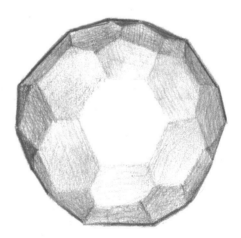

Modeling Organic and Geometric Forms

When you work with simple geometric shapes, it is fairly easy to see the planes or the structure of your subject. But working with organic shapes, it is not quite so easy.

In drawing this simple pear-shaped object, I modeled it using the sculptural method. This drawing illustrates two points. First, notice that the really strong dark areas do not begin until roughly the outer sixth of the form, toward the edges. The imaginary light spreads smoothly over the bigger planes that face the front. This keeps the big form from breaking up into smaller forms, and unifies the whole shape.

Second, you can see that there is only one highlighted area in the whole shape. Resist the urge to put highlights all over the place. You might feel that the thinner neck shape should have one, but that would bring that part of the drawing forward, up to the level of the globe-shaped area, when it is actually positioned deeper into the picture plane.

The success of this kind of drawing rests on sensitive modeling of the

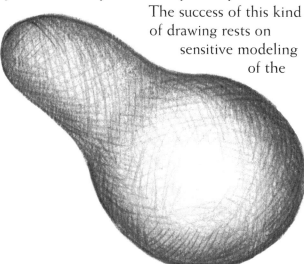

This pear-shaped form has been drawn as if the light comes from one point. The light would strike the base of the pear and then all other surfaces would appear to recede into dark. Crosshatching gives you extra control of your modeling as you work—you can always add more lines.

form. The first step: Establish your darkest dark. This is often the perimeter, the outline, of the shape. Next: Decide on your lightest value, usually the white of your paper. Then very carefully work between these two contrasting values. You must go by your sense of the form, not by what you actually see.

Drawing a sharp-edged geometric shape is more straightforward. It is simply a matter of adding a suitable tone value to one or more sides of the shape. For a subtle effect, try giving form to a shape that is one flat value by slightly darkening the edge where it changes direction.

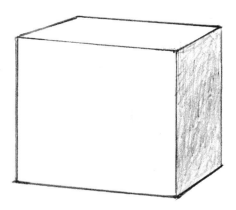

The light on this box comes from the upper left. Only the right-hand side would be in shadow, so only that side is shaded.

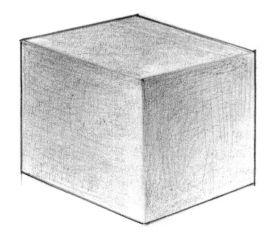

Darkening the corners and the edges on this cube gives a feeling of greater solidity.

An Exercise

This is a great exercise. It gives you a feel for the way values turn the various planes back into the picture.

Take a piece of white paper and crumple it up, about like my drawing below. Put it against a dark background and draw it.

The first thing you will find is that it takes a ton of patience to draw it accurately. Don't worry too much; just do the best you can. Your crumpled paper becomes a perfect example of a big shape, made up of little shapes. In this case, most of the smaller shapes have sharp edges, and it is easy to differentiate between them. Try to get the values of the different facets—each one is a shape—as accurate as possible. If you are like me, you will quickly give up and start faking it.

That is when you will realize that even a slight change of value will turn the form back. There are limits to how dark you can make things; if you make an edge too dark, your drawing will look as if you punched a hole through it! If your values are reasonably sub-

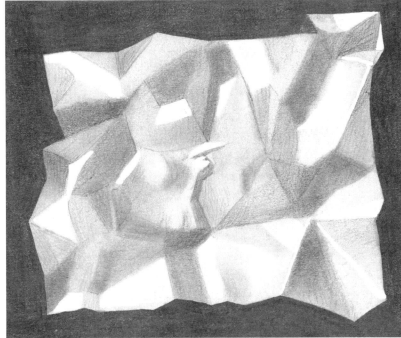

My crumpled paper did not look exactly like this. But my drawing is convincing!

tle and in the right places, your drawing will take on depth. You will also find that it is not really necessary to get each shape exactly the way you see it.

I should have told you that you should light the paper from the front, to approximate the idea that your eyes are the light source, but I purposely did not. If you don't use special lighting on your paper, this exercise serves as a lesson in sculptural modeling. If you set up a light, this becomes an exercise in drawing the light to add depth.

If you look carefully at my drawing, you might be able to see that my placement of tones is not totally logical (remember, I was faking it!), and yet the effect still comes off. It is true that the more accurately you render the light, the better the effect will be. So do your best to get it exactly as you see it at this point. But many great works are a combination of the actual effect of the light and an emphasis on the forms created by pushing the values. What your drawing looks like is more important than whether or not it is a perfect copy of something.

Looking at Light

Let's suppose that there are only two properties of light on an object. One is the area in light, and the other is the area in shadow. The halftone is in the light area, and the reflected light is in the shadow area. Everything in the shadow area is always darker than anything in the light area.

Look closely at light falling on an object. Shadows are more simple than you may realize!

Some art teachers have their students break down the halftones into those that belong to the light and those that belong to the shadow. To me, this seems unnecessarily complicated.

Think about light this way: As the light hits the surface of an object, it will be brightest where it hits the surface directly, and then the object will appear progressively darker as the surface turns away from the light. This is different than when your eye represents the light source: When you do that kind of modeling, the object gets progressively darker as it turns away from you.

Rounded surfaces usually have smooth gradations from one tone to another. Flatter surfaces have flat tones with sharp edges where the surface changes its angle to the light. If an object has a strong texture, that texture will be more apparent in the area just before the lighted area enters the shadow.

The halftones within the light area will darken very slightly until the light area meets the shadow edge. To blend smoothly into the shadow, the lighted area will be, at some point, almost as dark as the shadow. This slight band is called the penumbra. It is the only area in the light that can come close in darkness to the shadow area.

This transition area, from light to shadow, is very important. If you make it too wide, it will flatten that part of the form and give your drawing a muddy appearance. Unless this transition area really is flat, and you can actually see it, you should simply soften the edge of the shadow to give your form roundness. Never leave any doubt whether an area is in the light or in the shadow.

Shadows are actually areas in a weaker light, since there is usually some light hitting them. The darkest area (the core) of the shadow is usually located right after the light enters the shadow. The shadow area looks flatter than the lighted areas unless the object is under rim lighting (see opposite page) and the shadow areas become the main focus of the drawing. Often, the shadow has an area of reflected light from a nearby secondary source. This reflected light should never be as light as the darkest halftone in the light area.

Finally, look at the shadow the object itself is casting. This shadow is darker and sharper where it is near the object. The shadow diffuses as it extends farther from the object. A cast shadow can help explain the shape of things it is cast on—or it can distract the viewer from the main objects in a drawing. Handle it carefully.

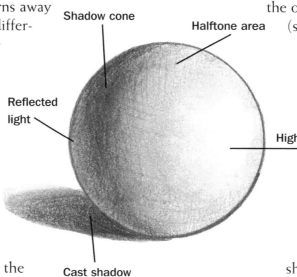

Shadow cone

Halftone area

Reflected light

Highlight

Cast shadow

Light Direction

Imagine light as an eye. Everything that the eye can see would be in the light area. Everything else would be in the shadow area. The planes directly facing the light are the lightest. Planes at an angle are darker in proportion to that angle. Things that are closer to the light are lighter than those farther away.

There are four basic lighting situations to work with:

Three-quarter lighting usually shows the form the best.

Rim lighting offers powerful dramatic possibilities. In this type of lighting, the shadow areas are rendered as though they are deeper, softly lighted areas, and the lights are almost flat. (Back lighting is shown the same as rim lighting, because there is usually some edge that catches the light and spills it over, around the edge.)

Side lighting can be a problem, because the straight shadow line can destroy the form if it is not used expertly.

Front lighting has a beauty all its own. It tends to emphasize the "oneness," the unity, in shapes.

There are other lighting possibilities, but these are the most used. If the light on your object was coming from directly above, or below, you could simply turn this book sideways in the appropriate direction to see these seldom-used effects.

Note that the light areas are a simple flat white in these demonstration drawings, and yet the forms still look solid. Until you clearly grasp this vital separation of the light areas and the shadow areas, this is the way I want you to draw things. Eventually, when you are ready to work into these light areas, do it very lightly, so delicately that you leave no doubt that these areas are in the light. The tone should be the lightest tone you can make and still have it be visible. When you do start modeling in the light areas, remember that the highlight on an area always falls inside the contour, even in back or rim lighting.

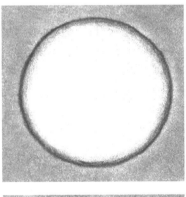

Front lighting

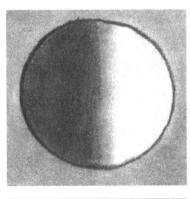

Side lighting

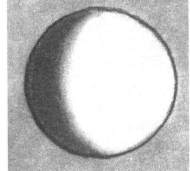

Three-quarter lighting

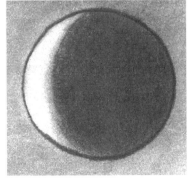

Rim lighting

Light on Geometric Forms

Let's take another look at geometric forms in light. This sketch of a house-shaped object shows that a drawing does not have to be perfect to capture the effects of light!

The object is white against a white background, and only one of the visible sides of the object is in shadow. The slanted roof is in halftone and is separated visually from the fully lighted front shape by a slightly darker tone. The shadowed side, along with the cast shadow, is darker than any tone you can find in the lighted areas.

Note that the side in shadow is somewhat lighter at its bottom edge because of light reflecting up from the lighted ground plane. It never gets as light as the halftone on the roof, even though I forced the edge of the roof plane to separate it from the brightly lit left-hand side.

Several edges have been lost in order to let the background tone integrate with the tones in the object. Also, the cast shadow is not accurately drawn; it has been softened at the edges to keep it from competing with the main subject.

Differing Surface Values

This drawing, of a stack of shaded cubes, shows the effect of light on simple boxlike objects of differing values.

For each "box," look at the side in the light. Now look at the side in shadow. Note that the relationship of the side in the light to the side in the lighter shadow boxes is the same in each case.

This drawing also shows that it is possible for a tone in the light to be darker than a tone in the shadow. (The light side of the bottom box is darker than the shadow side of the top box.) Obviously, this is not always true; it depends on the intensity of the light. Look carefully for the value relationships, and try to incorporate them in your work.

If you squint your eyes while looking at this drawing, you will notice that all the values in the shadow side can be reduced to one dark value, while the lighted areas remain separated. This is because there is less contrast between values in the shadow areas. The opposite could be true in a strongly lighted situation; the bright light would wash out the values. Again, use your eyes to confirm how something looks in a particular situation.

The human eye can see so many values that you as an artist cannot begin to re-create; learn to simplify what you see.

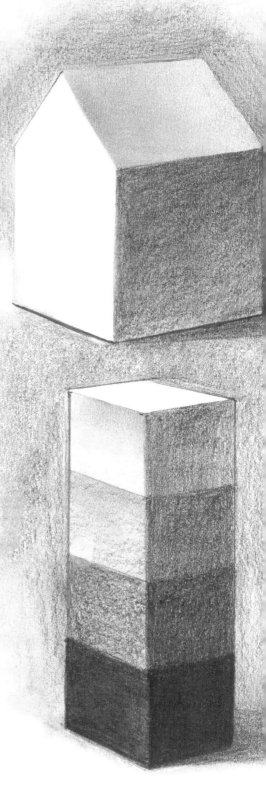

Here's our ball again. This time I have added two strips of gray around it to show how they take on the lights, halftones, and shadows of the ball. Note the darker shadow area on these strips; the two stripes almost merge into one dark value after they pass into shadow. This is partly due to the limited value range of your drawing materials.

In this case, the highlighted areas become slightly washed out. If you were working in color, they would also reflect the warmth or coolness of the light as well as the area they are painted on. Observe and capture these nuances or the stripes will not sit properly on their background.

Watch cast shadows. A cast shadow can be disturbing if it is not drawn mechanically accurately. The shadow must fit with the light effect on the object. Here, I blurred and shortened the cast shadow to keep it from getting too much space and attention.

Whenever you are drawing a flat plane that recedes from you, make it lie flat by adding a very slight tone to the deeper side—that is, the side that is farther away from you. If you are drawing the light, the object will be lighter closer to the light source. This is true whether you are drawing a sheet of paper on a desk in front of you or a field in a landscape.

On the Edges

Edges are the real "outsides" of objects, as opposed to outlines. Objects do not really have outlines; they have edges. All your handling of light and line will help you to create edges without necessarily using outlines.

Every form is surrounded by an edge. This edge can appear hard, or sharp; it may be soft, or fuzzy, or it may be completely lost against its background. Where the object is the same value as its background, the edge will appear soft. It will also get fuzzier when the plane is at an acute angle to your vision. It becomes sharper where the plane makes an abrupt change in angle at the edge. It will be sharper or softer depending on the texture of the object it encloses.

The treatment of edges can make or break a drawing or painting. Edges can even be manipulated, depending on your whim, to lead the viewer around and into the forms in your painting.

To draw a flat plane receding from you, add a very slight tone to the farthest side.

Sculptural Modeling

Darker tones seem to sink back into the paper surface, and lighter tones seem to come forward. These facts are the basis for sculptural modeling, a common way to draw forms that does not depend on the real-world lighting. Any subject can be rendered with sculptural modeling without regard to the actual light falling on the subject.

Be sensitive to different surface modulations and textures as you work.

This drawing of a mountain man is an example of sculptural modeling, using a random crosshatching of lines to form the tones that give the drawing its solidity.

I drew this picture from an old photograph. The picture was so bad that there was no possibility of understanding the light, so I modeled this by sculpting it. In other words, I faked the light by imagining that my eye was the light source, and then I simply "pushed back" the planes by giving them the appropriate tones.

This is a very complex shape and a very complex form. The man's head has deep indentations as well as smaller protruding forms. As a result, there are competing dark areas inside of the perimeter of the big form. The values of these

areas must be handled extremely carefully in order to avoid breaking up the big shape of the head.

I changed the features of my mountain man a bit from the photograph, which also illustrates that sculptural modeling is a common approach to rendering the form when you are working from imagination as well.

Sculptural modeling actually seems to be a very natural way to work for most artists, but there are a few other things that need to be considered when you work "sculpturally." Of

This mountain man came from a photograph—but the lighting came from my imagination.

course you need to have a clear sense of the bulk, or volume, of the subject. You also need to be very sensitive to the different surface modulations that it presents to you.

You can model a subject very broadly and simply, or you can render each slight turn of the surface that you can see, even adding some that you can't see. But you must do it with restraint.

The big thing to understand is that you have limitations in your value range. The darkest value is only as dark as your pencil or charcoal will go, and the white of your paper or chalk limits you at the other end. Establish your darkest dark tone early, because every other tone will have to fall between the darkest dark and the lightest white. If you start light and work towards dark, you will use all your values before you are ready.

Work by crosshatching lines to make your tones, as my mountain man illustrates, or use the flat side of your pencil lead or other drawing tool. In either case, you will need a delicate, controlled hand to get the lighter tones. If you like, you can smooth out your tones with your thumb, a chamois, or a tortillion, but don't overdo this or your drawing will lose its character.

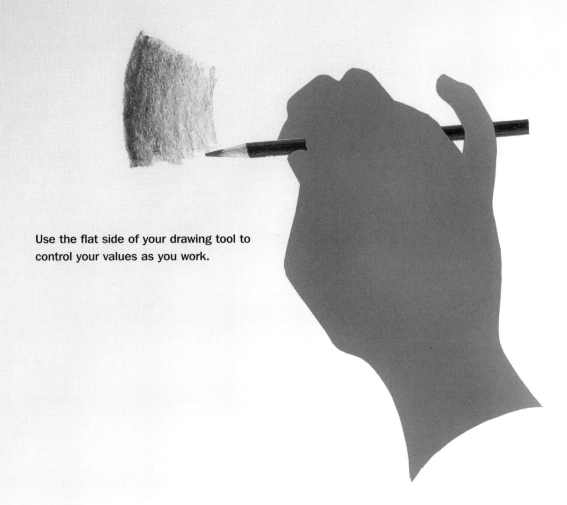

Use the flat side of your drawing tool to control your values as you work.

Using Lines to Show Solidity

Line is probably our most versatile tool, and yet, when it is used to make an outline of an object, it has no counterpart in nature. For some reason, we all can read a pure line drawing and understand its meaning, even though the real world has no outlines around its shapes.

Our eyes follow the direction of lines as they describe the shape of an object, and we accept them even when they move along the surface inside the outer contours of the shape. Creating these "interior" lines is the secret to showing the bulk, or solidity, of things when drawing in pure line.

The way a line is put down can powerfully suggest movement in living things. A line can be done carelessly or controlled. It has the power of suggestion when freely scribbled down, and the viewer's eye will often finish parts left undrawn.

As soon as you begin to draw one detail on top of another, such as a pattern on a shirt or even a random mark on the surface of an object, the viewer will immediately accept the object as solid and will have difficulty seeing it as a flat object. The more accurately you place these patterns or marks, the more powerful is the suggestion of solidity.

This drawing of a trumpet player illustrates how lines can be used to make a flat image seem three-dimensional, even alive.

The free-flowing line sets the light, happy tone of the drawing. As your eye follows the contour around, you will notice that the line is constantly skipping into and over the form and reminding us that there is more here than just an outline. The way that the player's left arm overlaps her body and her right hand goes behind the trumpet establishes the fact that there are several planes of depth.

Whether you are drawing realistically or whimsically, this magic asserts itself. Study every good line drawing you can find, and look for the ways the artist suggests solidity in his or her work.

This trumpeter is a simple line drawing—but your eye adds the depth that makes it come alive.

Patterned Surfaces

How do you sketch an object with a patterned surface and show its solidity? This information applies to all rounded surfaces, not just the figures illustrated.

Take a look at what happens to evenly spaced lines on a columnar surface. The same logic fits any simple curved surface with an evenly spaced pattern on it.

Note that there is little or no distortion of the distance between the lines throughout the whole middle section on the column. They remain essentially visually even until well over half of the width of the column has been taken up—the middle half. Then they close up rapidly to the edges.

There really are tiny changes in width, but they are so slight that they can be ignored in sketching. This is a handy thing to know when you are drawing the bark texture on trees, or columns on buildings, or any other vertically striped curved surface.

Now look at the ball shape. It is an example of this same observation, with the distortion of the pattern starting abruptly, near the edge, after a transitional row or two. The center contains all undistorted circles for more than half of the ball's surface.

If you were to start distorting the pattern closer to the center of the shape, it would have to be so subtle that the differences in the size of the "dots" could hardly be seen. If the differences were any more pronounced, the whole surface pattern would look wrong.

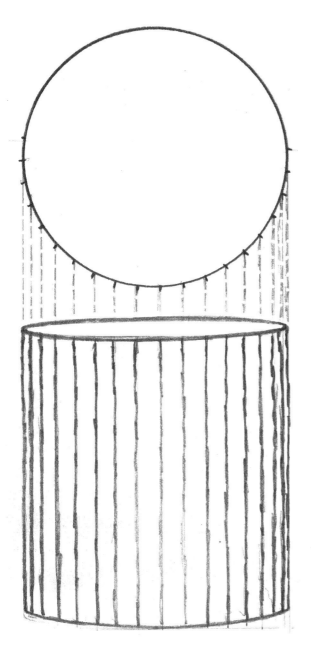

On a column, the lines in the middle section are evenly spaced. Then they close up as they approach the edges.

The Surface Sense

In order to draw successfully in three dimensions, you need to develop your own sense of the surfaces and the solidity of objects. Test and develop this sense by taking your own drawings or pictures of any kind, including photographs from magazines, and drawing lines to fit the surface of the objects.

Draw the lines as if you were drawing lines on the actual object itself. This sense can be carried to an extremely detailed state, following every bulge or indentation the surface takes. But, as usual, you get more out of sticking to the big simple curves that the form takes rather than getting too picky. This is called cross-contour modeling.

In these examples, I used my own pictures of our horse from earlier in the book. The top example shows how to use lines to reflect the forms of the horse and give a natural sense of three dimensions.

Back off from this page and try to see the drawings as flat shapes now. Once these surface lines are put in, it becomes very difficult to sense the flatness of the shapes, even though that is exactly what they are, of course: flat shapes. You have tricked the brain into accepting the shapes as solid.

Study the three-dimensional forms of your subjects.

You can also carry these lines around through the back side of the object, as though you were slicing it into sections. This may have no direct application to your work, but it has great value for training your senses. Obviously, when you do this, you are no longer seeing just the flat pattern. You are looking with full comprehension at all the aspects of your model.

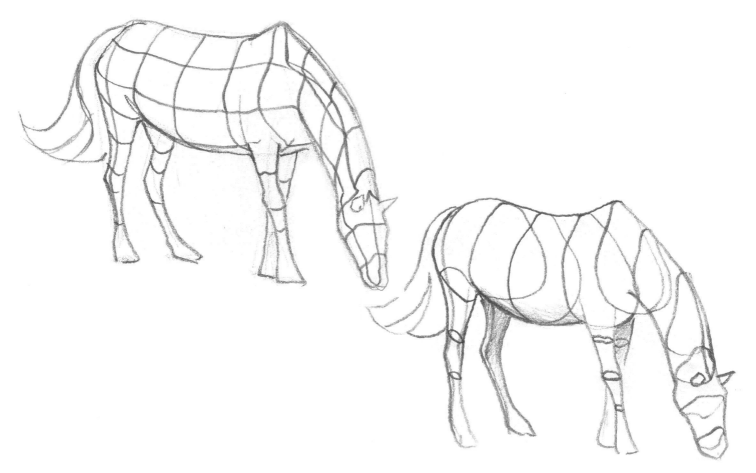

An Exercise

Like the crumpled paper that we used earlier, patterned cloth offers a wonderful exercise to develop your ability to sense the surface modulations on objects. It also demonstrates the power of a simple line to describe complex surfaces.

We all have striped or checkered dish or bath towels around the house. (If you don't have one, we'll wait while you run to the store to get one.) Throw one down on your desk where you work. Draw it carefully, taking note of all the curves and dips of the surface, as I have done here. Do it all with pure lines, no tones this time.

Look for other patterns as well, on other small pieces of cloth, and draw them using what you have learned here. (While you're buying the striped towel, look around for other interesting patterns—polka dots, diamonds, even swirls.)

Regardless of what you are drawing, start by looking at the overall shape of the towel. Then break it down into smaller shapes. On my example here, I divided the towel into rough thirds, because of the way it fell. The last step is drawing the pattern. There is

Practice drawing patterned cloth.

a tendency to forget about pattern when you concentrate on the surface of an object, but it is just as important to get these shapes right as it is when you are drawing anything else.

If you like, try rendering your towel with a sculptural tonal approach. If you imagine the light falling on the cloth, you will see that the pattern provides a new challenge.

Light on Figures

The human figure is one of the most difficult subjects to draw. Yet as complicated as these figures may look, they are still nothing more than a series of shapes that have been carefully rendered to suggest strong forms.

As usual, first I drew the shapes, then I worked on the modeling by drawing the effect of the light on the shapes. Simply by observing the shapes and edges of the shadows, and working in progressively lighter tones in the halftones and lights,

I got this effect of solidity. There is more on drawing the figure using shapes in my earlier book, *Figure Drawing Workshop*.

The human figure looks complex, but it is still made up of a series of shapes.

Figure drawing is the ideal way to study shapes and forms. I strongly recommend that you take a class in figure drawing if one is available to you.

4 The Sketchbook

Get a small sketchbook, write the word "SHAPE" on its cover, and take it everywhere. Let the label remind you to look for simple shapes in everything you see. Soon you will realize that everything you see can be reduced to simple, basic shapes. Sketching in your sketchbook—all the time—is the best training you can get.

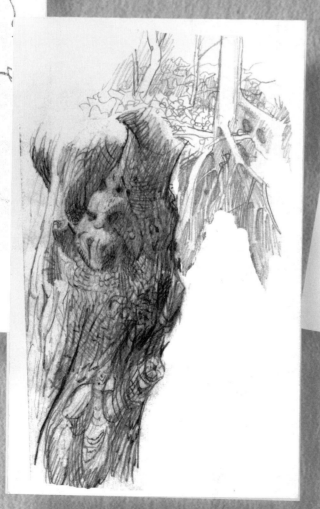

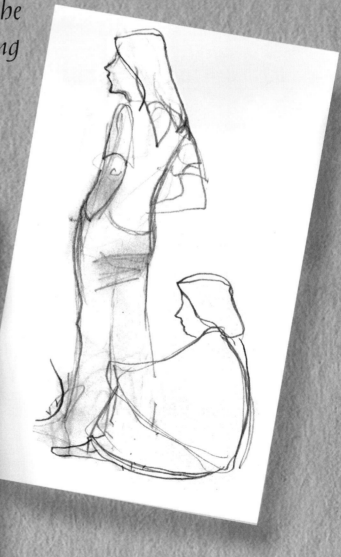

Using a Sketchbook

From here on, the subject of shapes becomes much easier—and considerably more fun. However, like everything else worthwhile, drawing still requires work. You cannot simply read about drawing and become an artist. You need to train yourself to see, think, and draw until the fundamentals become a part of you; and the only way that can happen is through the actual act of drawing.

A small sketchbook forces you to focus on drawing small shapes accurately.

You could draw every day for the next ten years without any noticeable improvement if you simply draw mindlessly without some serious concentration on specific areas of improvement. The study of shapes gives you a focus, and practically guarantees that you will be moving forward.

One of your most important tools will be a sketchbook that you can keep handy. Get a small one (mine is five by seven inches). The small size will force you to keep your shapes simple, but you should work bigger in your studio, so that you can work more freely. Write the word "SHAPE" on the cover so that you are reminded every time you open it to be constantly looking for simple shapes in everything you see.

Use your sketchbook often. Try to reduce everything down to the simplest shape possible, and put it down as quickly and as simply as you can. Get into the habit of looking for these shapes, and thinking how you would simplify them even when you are not drawing. Do not concern yourself with any of the details. Just big, simple shapes are all you should be concentrating on.

You should always be trying to improve your ability to draw shapes accurately. But when you are using this book, I want you to

You can draw anything in your sketchbook—even your sketchbook.

think a little differently than we have been doing. Now, we look quickly for the instant impression of a shape and put it down as simply as possible. In your sketchbook, you are not concerned with accuracy; you just want to get a shape down that reminds you of the thing you are drawing. It won't be long before you will realize that everything you see can be reduced to simple, basic shapes. But more importantly, you will find that slightly distorted and exaggerated shapes are more expressive than slavishly copied ones—and much more fun to do.

This is the best training you can get. Not only are you working with a specific focus, you will actually be drawing for short periods many times each day. Both of these factors have been proven to be the best way to learn any skill.

Drawing and Sketch Size

Why do I suggest that you use a small sketchbook? Because there is a difference between working small and working bigger. By starting small, you force yourself to stick with smaller shapes and to focus on capturing those shapes accurately. You will remain very conscious of these shapes when you work bigger.

When I am away from my studio, I work on my little five-by-seven-inch pad, but I work bigger when I can. Sometimes I use an eighteen-by-twenty-four-inch pad; other times, even at home, I will draw on a letter-size pad, a comfortable size for working from a television screen.

The big drawing on this page was originally even bigger than it is reproduced here. It was around fourteen inches tall. The smaller pictures were scanned off of my small pad, and only a little larger than the originals.

I drew the big girl, with the soda, from the drawing of the girl at the left in the little sketch. The larger drawing has been carried only slightly further than the original small-scale one. The little one took around a minute to capture, and the bigger one closer to five minutes. See how the size of the picture changes the effect?

Work up your little sketches later at home, but keep them free and loose as you draw from life. When you use your sketchbook, don't draw more than you can actually remember of the subject as you look up to see the model or object, then look down to your sketchbook. Keep your sketchbook shapes very simple, and don't get hung up on accuracy. You can draw a little more carefully later.

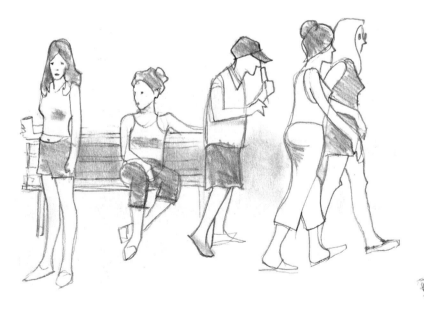

Notice how the small sketches are firmly based on shapes. The small sketch at the left became the larger sketch of the girl with the soda when I reworked it at home on a larger scale.

Quick Sketches

Fill your sketchbooks with quick studies of the things you see around you, reduced to their basic shapes. It is almost impossible to sketch people, birds, or animals from life without starting with each one's simple defining shape. Capture the shape, then work down to the defining details.

After you have practiced this enough, you will realize that you can start quickly and freely even when you are drawing highly finished pictures. The same techniques that you use for quick sketches will work for the finished work, as well. In fact, your drawings will have more life in them if you work in this way.

But for now, our focus is on doing super-fast sketches—from life, from your television screen, even from other pictures. This is the wellspring of all drawing and will give you endless hours of pleasure, once you get the hang of it. The whole secret lies in seeing things in their simplest, most basic shapes.

I have purposely left out drawing buildings or other human-made objects in this book, because if you can do the geometric shapes, as I suggested earlier, you already have the basic information you need to draw buildings, bridges, boats, and most other objects made by people. The principles remain the same no matter what you draw.

For most of us, natural shapes are far more interesting to work with. Let's look at cats—an ideal subject for us to begin with. They are perfect examples of the beauty of fluid shapes. They offer an almost endless array of natural shapes to study. They love to rest in all kinds of interesting positions. And many of us have one at home already, or at least have a friend who does. Also, bookstores and many magazines are full of photographs of cats, so there is no shortage of study material no matter where you live.

The sketch below shows how you should be working in your sketchbook at this time. Drawings should look like drawings. Notice the big, simple shapes, and how they carry all the information necessary to show you what the cat is doing. Every line and shape has its job: Notice how, if you cover the head of the cat, you would not be able to identify the drawing as a cat at all.

This loose, free feeling in a simple sketch often has more excitement and life in it than more finished drawings. It is actually an enlargement of a much smaller sketch from my sketchbook.

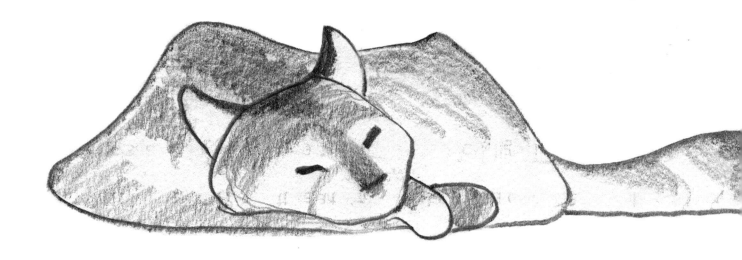

Surface Patterns

This charcoal pencil drawing was made from a photo of Kijafa, a long-departed friend. It is a portrait, and to my eyes it is much too carefully rendered—it looks more like a photograph than a drawing. But it is a perfect example of something you should be aware of.

In a subject with such a powerful pattern as this, you would look for the big overall shapes that reveal the form first. Then you would superimpose the surface pattern shapes later. These surface patterns can break up or camouflage the big forms, and they are especially difficult to handle when they are so high-contrast. It is hard to ignore such powerful shapes; let them help you by revealing the form rather than hiding it.

Big Simple Shapes

Cats are very unself-conscious models. Here are a couple of pages of quick sketches of our cat, originally drawn somewhat smaller than the size you see on this page. Although some of the poses are almost identical, some of these drawings show how subtle changes in the shapes make big differences in the apparent attitude of the cat.

Each of these sketches took only a few seconds. They are just the raw essentials of each pose, and yet the whole attitude of the cat is explained in these few lines. Even when a cat seems to be resting, it is continually moving: scratching an ear, lifting its head to see something, or just plain trying to drive you mad. So you must learn to get it all down quickly.

Start with your cat in a relaxed sitting position. Begin sketching. When the cat moves, begin drawing the new pose, but be ready to go back to the first one, because a cat will often get right back down again, pretty much as it was before.

Shapes Within Shapes

It is almost always easier to draw the overall shape when it is made up of several smaller shapes. There is one sketch here where I tried to get the whole thing in one shape, but it probably would have been better if I had built it with at least two shapes. Be aware of these smaller shapes, even if you don't actually draw them.

Look at each of the drawings on these two pages. In each one, identify the biggest simple shape and the smaller shapes within it. Remember these shapes as you work with your cat model.

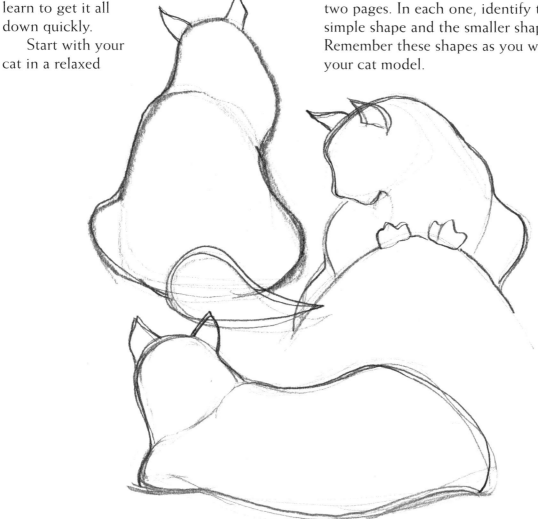

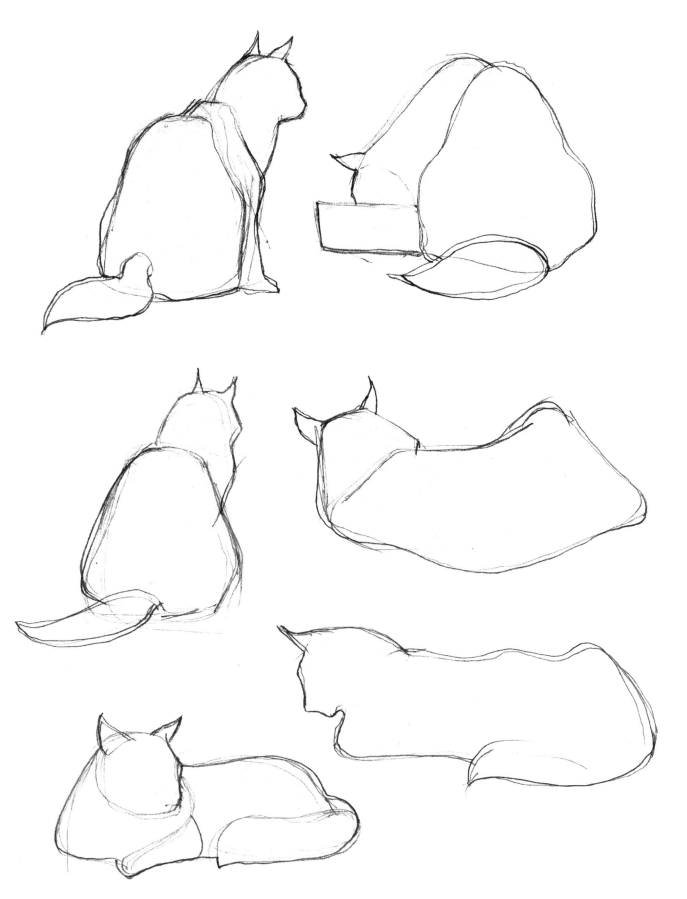

Capturing Shapes

When you are working on your quick shape sketches, focus on pinning down the basic shapes of the subject in as little time as possible. As you look at my drawings, note that the shapes have some of the flow of movement and a hint of the cat's structure in the basic shapes, even though the drawings reduce the animal to its simplest form. Try for the whole shape when possible, but don't hesitate to break it into several simple shapes if it helps to see it better.

The shapes on this page are all made up of two or three smaller shapes. While this will help you get the proportions better, you must be careful not to let the pieces break up the flow of the whole shape. The smaller shapes must work together and flow into one another. Eventually you will be able to do this by eye alone, but it really helps to have a knowledge of the basic structure of the thing you are drawing.

If you are having trouble getting the shapes, here is a hint. Look for a vertical line in the contour of any shape, and draw it first. That will get you started on the right foot. If there is no vertical edge apparent, mentally superimpose a vertical line. This is a big help with all but the flatter horizontal shapes; try it. It may give you that slight edge you need to begin drawing with more confidence.

Try these quick-capture drawings for a while, but don't become too discouraged if you get nowhere in your first attempts. Believe me, this is much harder to do than it looks. If you get discouraged, go back to almost geometric shapes and practice those for a while. Then proceed to a simpler, more geometric version of drawing cats, as I explain on the facing page.

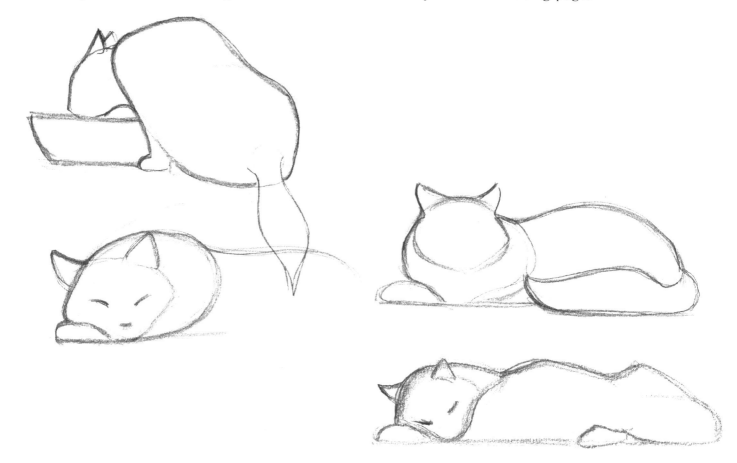

Almost Geometric

At first glance, the drawings on this page might seem pretty basic: We are getting more geometric. But don't skip past it thinking that you are too far advanced to get anything out of doing them this way!

On this page, I am showing you how to take an organic shape and break it down even further than we have done previously. Here we are reducing the organic shape to its basic geometric elements.

Look for the big shapes, then the secondary shapes within them.

This really forces you to see the biggest simplified shapes, and it will show you what to look for. Even highly trained artists benefit from reducing things down to their basic geometric counterparts. Some artists even go farther into the abstraction of these shapes and make it a centerpiece of their finished work.

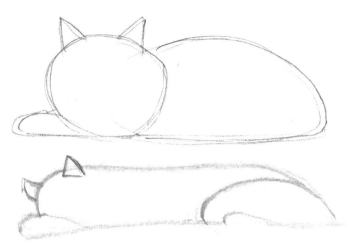

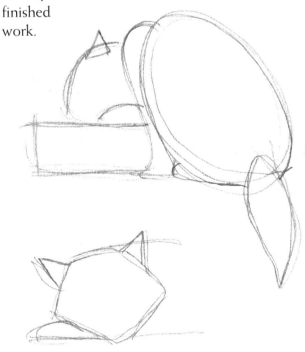

In these drawings, the main things I want you to be very conscious of are the overall proportions of these shapes (the length-to-width ratio) and the orientation (the direction; see page 38 for more on orientation). Try doing sketches such as these. Do them quickly and very lightly, so that you can work into them to develop them further later.

Look for the real shapes, not the shapes that you think are there. The huge head shape in the sketch at top above is not the outline of the head; it is the outline of the heavy ruff of fur around the cat's neck. This shape was more obvious, easier to see as a simplified shape. Determining this shape and defining it makes placing the head much more straightforward.

After getting these simplified geometric shapes down, you will be able to shape up the contour more like the sketches on the previous pages. It will also be easier to see and define obvious secondary shapes within the big shapes.

You will find that when you have developed a little confidence and you are quickly filling your sketch pad with information, you will be able to put your shapes down a little stronger and more quickly as you see them. Then, if your model gives you more time, you can develop the sketch until the cat moves. Stop working when the model moves. Often, your best drawings will be the ones that you thought were unfinished . . . but you won't know it until later.

Simplifying Complex Shapes

The large, finished picture at right is a portrait of a beloved friend, Tequila. It is a good example of how far you can take a drawing by thinking in basically geometric shapes.

Tequila was very sick, and I knew we would have to put him to sleep within hours of the time I did this portrait. I wanted to capture his personality as well as his likeness. This was a "last chance" effort, and emotions were running high. And so I was especially careful with my first shapes, as well as the placement and relationships of all the subsequent details.

Instead of step-by-step demonstrations, I will show you exactly what I was looking for as I worked. Since poor Tequila really did not look like his normal self anymore, I referred to a less-than-satisfactory photograph, as well as taking occasional looks at the cat as I worked.

I started with a very loose, light line that approximated the shape of the whole drawing, so that I could fit the image properly on the page. Then I carefully considered the four roughly geometric main shapes that made up Tequila's face. I put them in very lightly, starting with the big shape first.

Then I placed the three remaining smaller shapes as exactly in their relative positions as possible, noting that they were all about the same size. If you look at the small circle, you will see that the corners of Tequila's eyes barely touch the top of the circle, and the

nose is in the center of the circle. The edge of the circle just breaks the lower edge of the main shape. This is how you relate shapes accurately to one another.

Now I could place the nose with confidence that it would be in the right place.

After that, I could clearly see the nearly rectangular shape that runs upward from the corners of the nose and flares out slightly to form the inside edges of the cat's ears. Some of these things I simply noted, without actually drawing them.

Then it was easy to position the eyes alongside the edges of the flared rectangle, carefully relating their size to the width of the space between them. Notice that the top lines of the eyes would be practically horizontal if the head were level; and if I continued the lines across the bridge of his nose, they would form an almost straight line.

Now the batwing shapes on either side above the eyes became very apparent. This is where seeing "flat" comes into play. (Look at the finished drawing. Can you see the batlike shape on Tequila's forehead)? The mouth practically told me where it went at this time.

With this basic road map established, it was simply a matter of carefully relating all the tiny details to the existing framework. If this framework had been off, even slightly, it would be next to impossible to get a likeness, either of a person or, in this case, a cat. Portraiture is probably the most exacting type of drawing, and yet a really good artist can

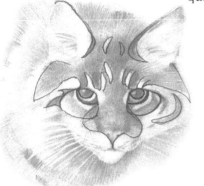

and does take liberties with the basic structure to emphasize important qualities of the sitter.

Now you can look for the little patterns that the markings and the other shapes make as they fit together into the puzzle of the particular face you are drawing. Here, I was especially concerned with the size and position of the pupils in Tequila's eyes; they are crucial to the expression I wanted to capture.

At this stage the values, as they relate to one another, need to be very sensitively worked out, so that you get your emphasis where you want it. In this case, it is his eyes. Seeing this picture makes me remember Tequila's personality as well as the way he looked. In that way, it gives me much more than a photograph does.

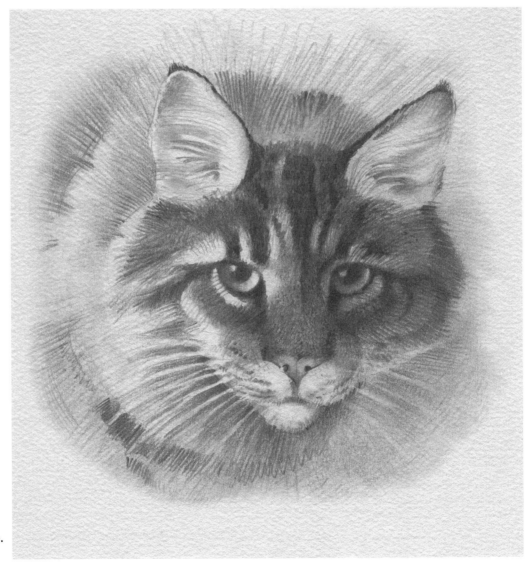

My portrait of Tequila captures his personality as well as his appearance.

People Shapes

Now let's get back to our sketchbooks. Pack yours up, and head out to a favorite spot: a shopping mall, the beach, a restaurant, the zoo—go wherever you can relax and find something going on. You can even plop down in front of the television set and work, if you want.

All you need to do is look for the big shapes in front of you and sketch, sketch, sketch. Do a million of them. As long as you are enjoying yourself, you will improve.

Unless, of course, you are still looking at the details. Then you will be frustrated. Quick sketching from situations with people, animals, or birds requires lightning speed. You have no time to think about anything, so you need to grasp the big overall shape and put it down instantly. If you have practiced your shape drawing, this is where your work will pay off. The principles of shape drawing will have stuck with you and will automatically assert themselves as you try to capture the images in front of you.

Whether you are drawing trees, people, animals, or anything else, you approach the drawing in the same way. It is true that there is an extra element to be considered when you draw living things, but if you are properly looking at the big shapes, and getting them even close to right, you will get reasonable results.

There is a big difference between a sketch and a classical drawing. When you are taught drawing in the classical sense, you usually measure and line up all the details just as you

see them, as I did in the portrait of Tequila. Then you carefully render the light aspect until you have a believably solid drawing of your subject. This can be a painstaking and time-consuming process, but the results are very impressive if it is successful.

I find that a combination of this more intensive approach and quick, free sketching is the best way to bring out your own personal style. However, a period of practice and study is excellent at first to give you the discipline you need to get an element of control in your sketches.

When you work in your sketchbook, you are usually simply sketching. This means you do not measure things, or even give them too much thought as you do them. Just look for the big shapes and draw them as simply as possible. Then, if you have enough time, you can develop them later.

Snapshots

These pages show drawings from my sketchbook. I did each one in just a few seconds, because the subjects moved around so much. In fact, some of the people were moving as I drew them. Can you see how I tentatively put down loose, scratchy lines to feel out the placement? All I was trying to do here was capture the big basic shapes—there was no attempt to put in any tones or anything else.

Try to capture the shape as well as the extra element that makes each person an individual.

These sketches are not works of art, yet when I look at them now, I am carried back to the places where I did them. This is because they contain only the basic essentials. They were made simply to force me to see the important stuff first.

Quick Sketching Heads and Faces

The human face is the most fascinating challenge for most of us. There are millions of them, and no two are exactly alike. They can be grouped into a fairly limited number of types, but even identical twins usually have discernible differences.

Until you learn to look for simple shapes in your subjects, you will find it nearly impossible to draw identifiable heads and faces. Once again, if you concentrate on the details, you are lost. But it is surprisingly easy to capture likenesses if you look for the big, characteristic shapes first. This kind of drawing is different from the type of drawing I demonstrated earlier in the portrait of Tequila, since there is no measuring or even long careful deliberation before you begin.

When you are forced to work fast, as you must when sketching from unposed models or television, you have to resort to a caricature approach. You could also use this approach for longer, more studied sketches from other sources, such as drawing from magazines or freeze-frame videos, or even drawing from posed models.

What do I mean by a caricature approach? Look around you. Every face has a characteristic overall shape. In some people, this shape is very obvious, and in others, it is harder to see. This shape, along with the positioning of the features, is what makes a face recognizable. Usually, a simple dark mass of the approximate size and shape of the feature is all that is needed to make the face recognizable, if the features are in the right positions.

The drawings on this page demonstrate three stages of a quick sketch. Although it was drawn from a newspaper photo, I did it very quickly, in about a minute, as if I were sketching it from life. The woman in the picture had a fairly prominent jawline, and the shape of the face in the first sketch exaggerates it. Since I was practicing working quickly, there was no time to change it. I left it alone and finished the sketch.

My first reaction to the shape of her face resulted in a finished sketch that suggested the woman's face, but it is more a caricature than a portrait of her. Still, this final drawing does look like the woman in the photograph. Quick sketching will often give such exaggerated results—but sometimes they are more honest than drawings you take your time with.

If you are trying to draw a caricature, keep the finishing process very simple. A distorted face that is too realistically rendered can look ridiculous rather than humorous. You can get away with far more distortion if your rendering is simple.

The basic sketch becomes a caricature.

Modifying the First Shape Map

As we learned from the first set of three drawings, you are often considerably off in your first shape when you work fast. Nevertheless, having something on your paper that you can compare with your model will be a big help to you; do not let it inhibit you as you develop your drawing. Use very light, sketchy lines in the early stages to prevent a feeling of discouragement.

The first drawing on this page is the same as the first stage on the previous page. Instead of finishing it with its obvious distortions, however, I modified it before the finishing process. The second drawing shows how much altering had to be done to bring it into a moderately accurate match for the model. The double lines show where the changes were made.

Since I was working from a photograph, I had the time to study my model and my drawing carefully. In all, it took me a little more than three minutes to finish this version of the picture. This is not a good portrait of the model, and you would not expect it to be a perfect likeness in so short a time, but it has her basic characteristics. To get a really good portrait requires great concentration, and considerably more time. The whole drawing rests on the big basic shape of the face and the exact placement of the features. No matter how beautifully rendered the features are, if these two things are off, the portrait will fail.

Don't be too quick to discard first sketches. The best portraits are often a mixture of caricature and solid observation. A caricaturist will often do dozens of fast basic shape sketches before getting one that satisfies him or her, and he or she may well use these first sketches for the finished work, because they are so hard to duplicate.

Any view of the head can be reduced to simple shapes. Side views are easier to draw than the other views, but they are all easier when you see them as a simple shape first. Do not draw on the features right away; just get the big shape, and put simple marks where you will position the features, as I did in the middle sketch on these pages. When your rough sketch begins to suggest your model, you are getting the idea.

You have probably noticed that I haven't given you any formulas for pretty faces or any of the usual "start with an oval" theories yet. The face is not a simple oval. It is made up of several characteristic shapes: the shapes of the hair, the face, and the neck as it supports the head. Why would you begin with an oval when you have far more to work with in those three shapes? Look for the real shapes in front of you.

 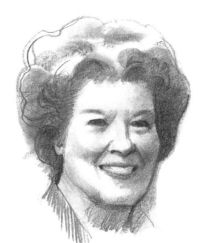

The basic sketch is modified to become a portrait.

The Shapes of Birds

Birds offer the perfect subject for the study of shapes, and patterns. Once the artist gets over "the feather phobia," which is what I call the inevitable preoccupation with rendering every feather with all its details, he or she will begin to see the awesome beauty in its simple shapes and patterns. Then you will be hooked for life on drawing and studying these little jewels of the natural world.

At first, birds seem deceptively hard to draw. They move so fast that it is nearly impossible to see the movement. One minute they are in one position and the next in another; the movement can only be described as a blur. And birds very rarely sit in one position for long, especially when you want them to. But if you watch them, eventually you realize that despite their incredible diversity, there is really a similarity among birds that makes them quite easy to draw after you understand their basic shapes.

The trick is to look for the big feather masses, and draw the shapes of those feather masses while ignoring the individual feathers.

Songbirds, birds of prey, migratory birds—even a parakeet offers a chance to study nature's marvels.

After you have the basic shapes right, you draw in the big patterns, still ignoring the individual feathers. Once you have gotten all the important stuff right, you might want to concentrate on a feather or two, probably in the wings or tail, but keep them to a minimum.

The study of bird structure and anatomy is a necessity for anyone doing finished bird paintings, and it is a thoroughly absorbing subject. Even if you do not intend to specialize in birds, they offer a great way to study the shapes, patterns, and colors of nature.

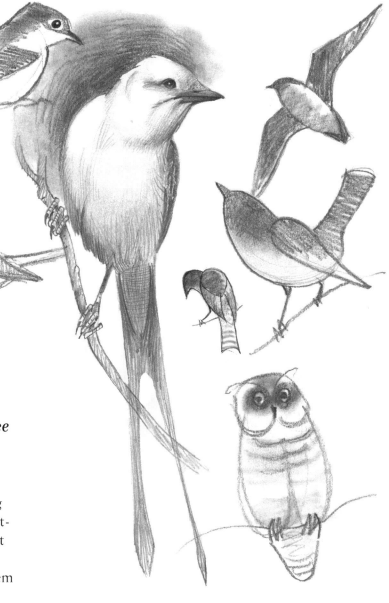

The Shapes of Animals

We have practiced drawing horses and cats. If you live near a farm or a zoo, take the opportunity to draw other animals. As with cats and people, you are looking for the big, simple shapes, and trying to draw them as quickly and as well as you can.

Draw animals as they really look, relating the small shapes to the bigger ones.

The examples here are cattle and goats. Notice that animals do not always look the way you may think they look—goats have much longer bodies and more tapered legs than you may realize. Look how the ears flop down, how the udder does not hang very low, and how the nose is almost squared off.

Draw the animals as you see them, trying to relate the smaller shapes to the bigger ones the way you find them. Note that each sketch is made up of several shapes. Try to get these smaller shapes properly related in size and position to one another and to the big shape. Then you can develop your drawings by adding tone and shading to make the animals three-dimensional.

Do not improvise; you are training your eyes to see, not strengthening your imagination. As you gain knowledge of your subject from study and observation, your knowledge will help you see things more clearly, and this will show in your work. But you should be able to get a creditable image without any special knowledge from pure observation alone.

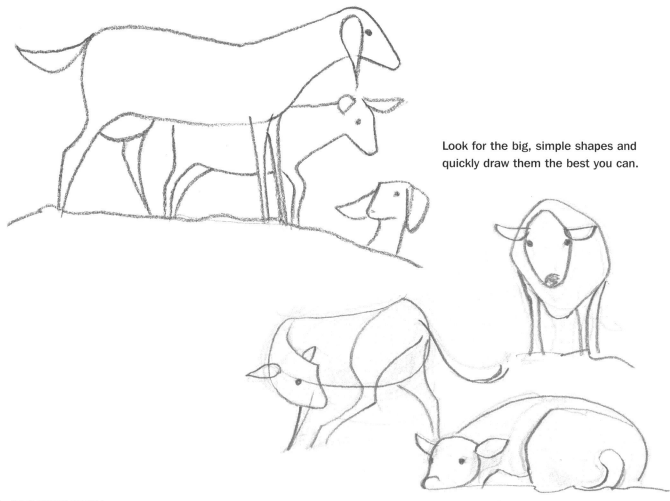

Look for the big, simple shapes and quickly draw them the best you can.

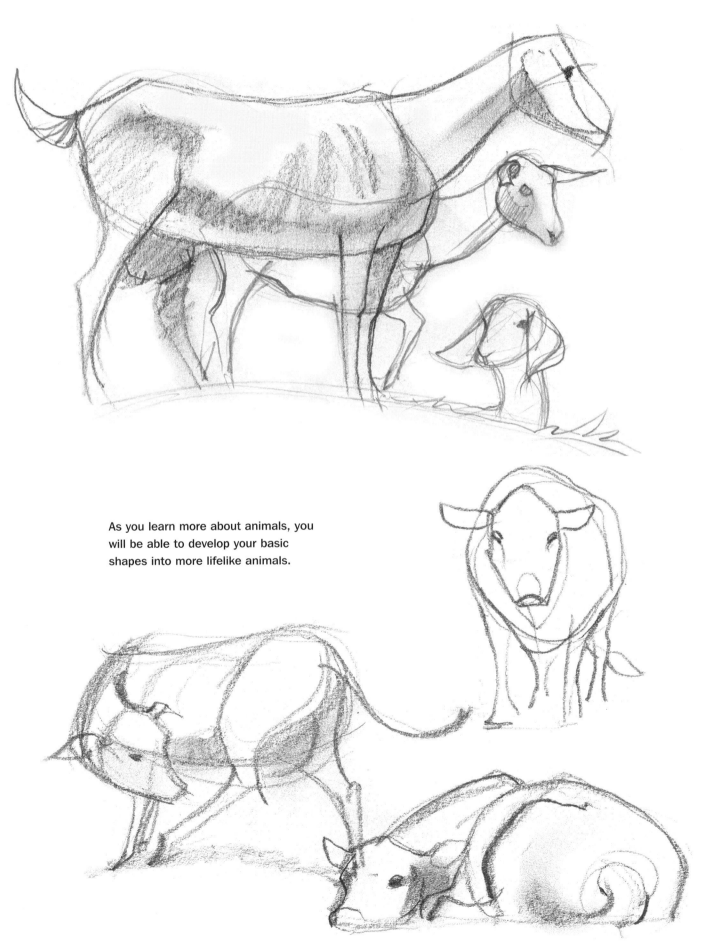

As you learn more about animals, you will be able to develop your basic shapes into more lifelike animals.

Moving Models

When you are sitting in the mall, the park, or wherever you have chosen to sketch, you will quickly notice that your models might not want to hold still! When drawing moving models, watch carefully and look for the action line. Where is the main movement of the model's body taking place?

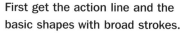

First get the action line and the basic shapes with broad strokes.

Here is an example of using action lines to capture moving models. The simple doodle is about all I could get from a scene in a shopping mall, because the girls were moving as I sketched. A blink of the eye was all the time I had to record the movement before it changed to something else. Notice that these first few lines captured the basic action of the two figures interacting. They were made with a light, broad stroke from the side of my pencil lead.

Then I got another few seconds to get a fleeting impression of the shapes in my mind as the girls stepped forward into the approximate pose again. After that, I had to work from memory to get the second stage—the next sketch. All this was done in approximately one minute.

Then refine the shapes.

For the third sketch, I added a few tones to separate the shapes from one another.

This action-line method helps you keep your sketches simple and does not give you a hard outline that might inhibit you as you work to refine your sketch. It also gives you a framework to build on to organize your shapes.

It is very important to keep the flow of action as you develop the shapes. You can quickly lose it if you start picking away at smaller details in these stages.

The last of these three sketches reflects the level of finishing you should be doing on your sketches at this time. Do not concern yourself with facial features, folds in the clothes, or other smaller details yet. Look for the action flow in the drawing, and the big simple shapes. Although these sketches seldom produce masterpieces, they offer a great deal of value from the quick sketching and intense concentration you practice to get them.

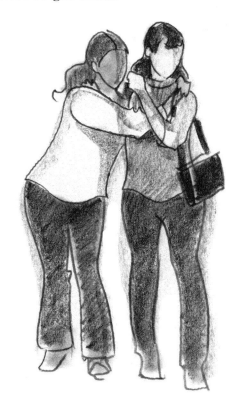

Finally, add tone to separate the shapes. This sketch is finished!

The Action Line

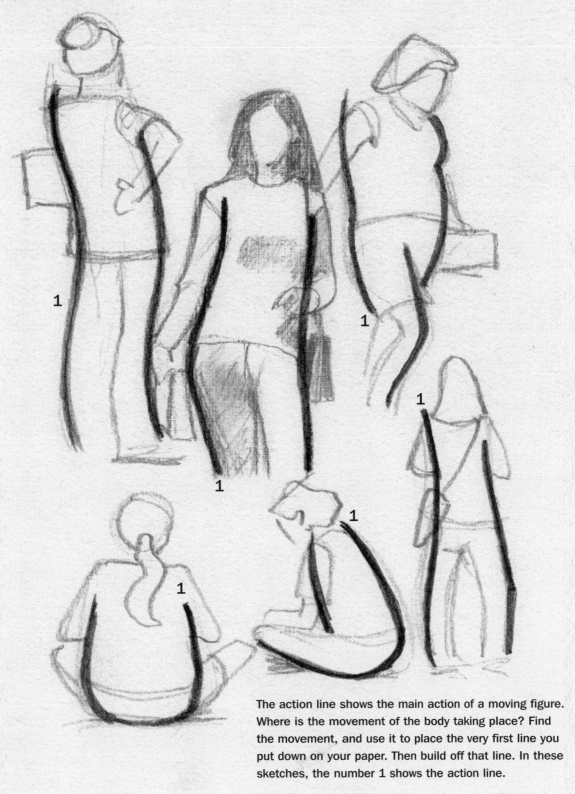

The action line shows the main action of a moving figure. Where is the movement of the body taking place? Find the movement, and use it to place the very first line you put down on your paper. Then build off that line. In these sketches, the number 1 shows the action line.

Capturing Movement

People going about their daily work or play present a huge challenge to the new sketcher. In many cases you barely have enough time to see the action, much less sketch it. Even looking for the simplest shapes won't do it.

You need a kind of shorthand: Draw the action as you feel it. Usually all it takes is a few lines flowing through and around the big movement of the figure. This is the gesture, a sort of framework on which you hang your shapes from memory after the movement has taken place. When you have learned to do this, you will find a new life in your drawings. The action line, which I discussed on the last two pages, will start you off in the right direction. Here are some more examples of how to develop a framework of movement.

This little guy was at the beach playing with a rubber raft. He was squirming around trying to get aboard the raft, and he offered one of the hardest subjects imaginable to draw.

The six sketches on the left side of this page are the result of waiting for an interesting pose and quickly looking down at my paper to put down my basic impression of it.

Then, in each case, I took a few seconds to build the basic shapes over this framework to get the results in the six sketches on the right half of the page.

Start every drawing with these simple, light gesture lines. More examples are shown opposite. Look for the action, look for the gesture, and look for the big shapes. Working this way sets up a flow that carries over into all your drawings and adds a sense of life to them.

These small drawings of the boy and the raft are only slightly smaller than the size they were drawn in my sketchbook. The problem with working this small is that you can't get much feeling or flow into your shapes, but that is offset by the fact that you can't get too fussy either. The small scale forces you to see things simply.

When you get back to your studio, it is time to work bigger from these sketches while they are still etched in your memory. Keep the lines flowing smoothly, and draw what you actually remember. Try not to fake things if you don't remember them clearly.

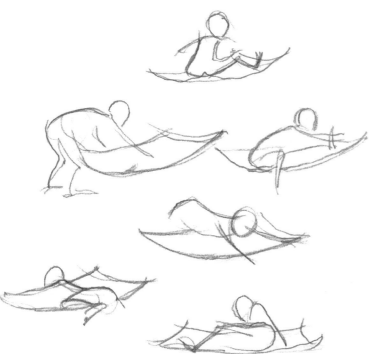

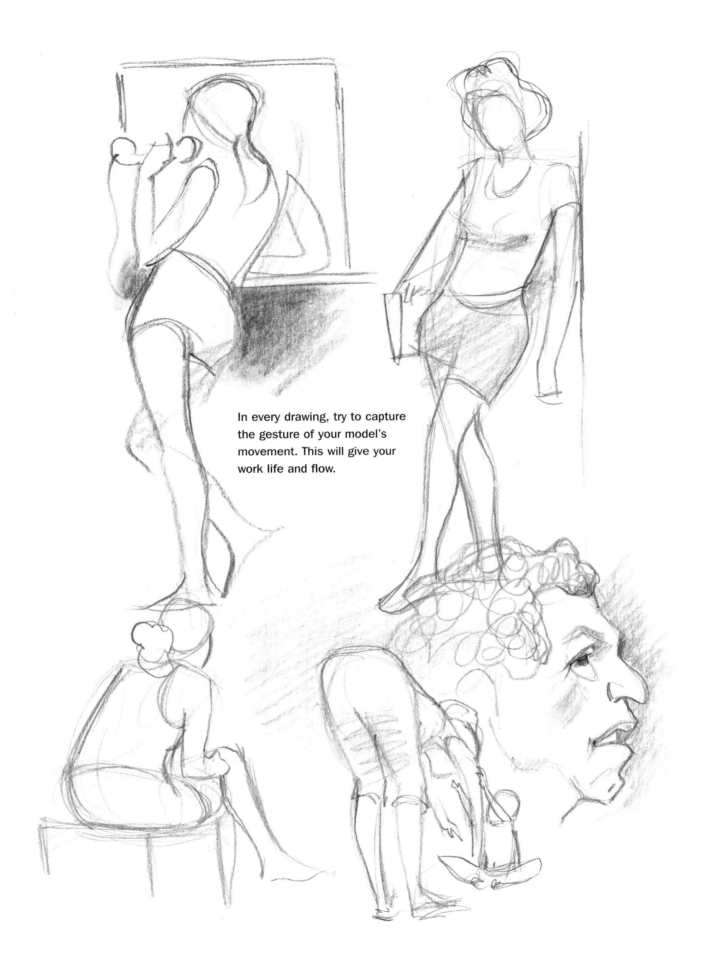

In every drawing, try to capture the gesture of your model's movement. This will give your work life and flow.

Finishing a Simple Sketch

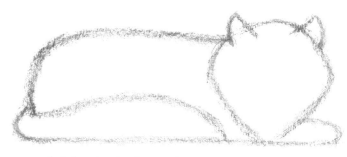

Get the simple shapes down.

Develop the sketch with rough shapes and very basic tone.

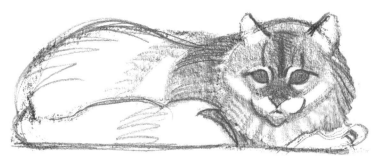

Add tone to make the drawing three-dimensional. Work carefully here to keep your mental focus flat.

What purpose does all this fast sketching serve? What good does it do to draw the simplest lines and shapes when the models really do not look that way?

In addition to training your eye to quickly see the important factors of shapes, and your hand to draw them, these simple shapes, when put down correctly, can be developed to any degree of finish. You have to start somewhere, and it is much easier to start from there than from a blank sheet of paper.

Let's return to our friendly cat model to show, step by step, how to finish a simple sketch. Before we begin, remember that when you are sketching, you need to judge appropriate shapes and gestures, and you have to get your shapes down at the right relative sizes and proportions. Capturing gesture and action require consideration and practice as well. This simplification I recommend just helps you do it faster.

Now let's look at these sketches. In the top picture, my first basic rough sketch, I held my pencil flatter to the paper so that I was making a fairly broad line, and I kept the lines light (lighter, actually, than it is reproduced here). The broad line forces you to see things even more simply, and it leaves some room for interpretation when you develop the sketch, because you are less inclined to try to stay on the line. Look over at the final drawing and notice how little it needed to be altered from the original sketch. Get these first simple shapes as correct as possible.

There is no doubt that it makes more sense to get everything right the first time. But don't let that inhibit you from working quickly and changing something if you realize that it is wrong. Once you get something right, it gets increasingly easy to get everything that follows right by comparing it to the things you know are right. Don't just keep compounding your errors.

In the middle picture, there was only a little development from the first sketch. The rough shape of the cat's head was quickly but carefully put in, and the eyes were positioned with simple blobs of tone. The position of these features is much more important than the details, so they are simply nondescript dark shapes at this point.

The second shape in the body was now added, and a little work at the tip of the

cat's tail was done. Now the cat is starting to look three-dimensional. From here on in you have to be on your guard not to stare too closely or finish any one area before you go to the next. As I show in the bottom picture, you need to keep all the areas developing at the same time or you will switch your focus to your intellectual side and it will be difficult to see the cat in terms of flat shapes and contours. Let the artist within you make artistic decisions.

This demonstration should show you that once you get something down that is reasonably close to your model, you could carry your drawing to any degree of completion desired. If I wanted, I could have rendered this drawing so far that it would have been more detailed than a photograph. And so could you.

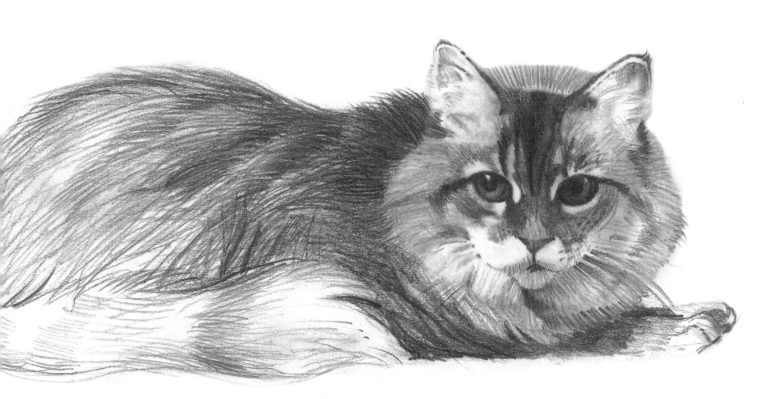

Finish the picture.

5 Trees

Each tree presents a fresh challenge to the artist. Learn to see a tree as one overall shape, then add the leaf masses to give the tree a feeling of solidity and individuality. Study and understand your subject in order to capture the life in every example.

The Silhouette

Remember our silhouettes of cats earlier in this book? Nowhere is the silhouette more important than when you are drawing trees. They are the perfect subject to get you thinking right and to make a lasting impression on you about the importance of the big, simple shape, and the trap of details.

When you draw trees,
you are truly drawing a portrait
of a unique living individual.

Trees and shrubs are one of the more difficult and frustrating things to draw until you get in the habit of seeing and drawing their simple shapes. Then they become an endless source of pleasure as you draw and study them.

In this chapter, I am going to teach you to see "broadly," the way trained artists do. If you learn this, you will get much more pleasure out of drawing. It will no longer be the hard work that it is when you get all bogged down in details. You will come to understand that the little details are not only unnecessary in a good drawing, they usually are a hindrance to presenting a clear, aesthetic message to your viewers.

Trees offer the ideal model for us because of their special quality of life. They are actually living things, and you need to get that feeling of life into your drawings.

While absolute accuracy is not necessarily desirable in portraying trees, a different kind of accuracy is vital. This is the ability to get the character of the tree, and most of this character is to be found in its basic shape.

As it grows, each tree takes on a different form, depending on its position relative to other trees and to obstructions nearby, as well as wind and other factors. You must be able to see and convey the unique, living, developing quality of your model, or your trees will lack conviction.

Trees will stand reasonably still for us, yet they are ever-changing. They allow us to return over and over for deeper study. Trees are also a major part of almost every landscape drawing or painting. You will not be able to draw convincing landscapes until you can do beautiful, expressive trees.

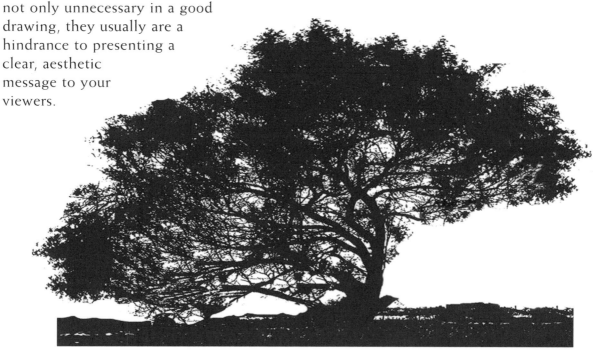

These pictures illustrate what I mean when I say you need a different kind of accuracy to do expressive trees. I took the photograph of the little tree on the facing page and, using a computer, drastically altered the proportions and size to get the tree on this page. Notice that the beautiful, natural flow of the branches into the foliage mass is automatically retained, even though the overall shape was completely changed. In drawing trees, you work to capture the essence of the tree rather than create a slavish line-by-line drawing.

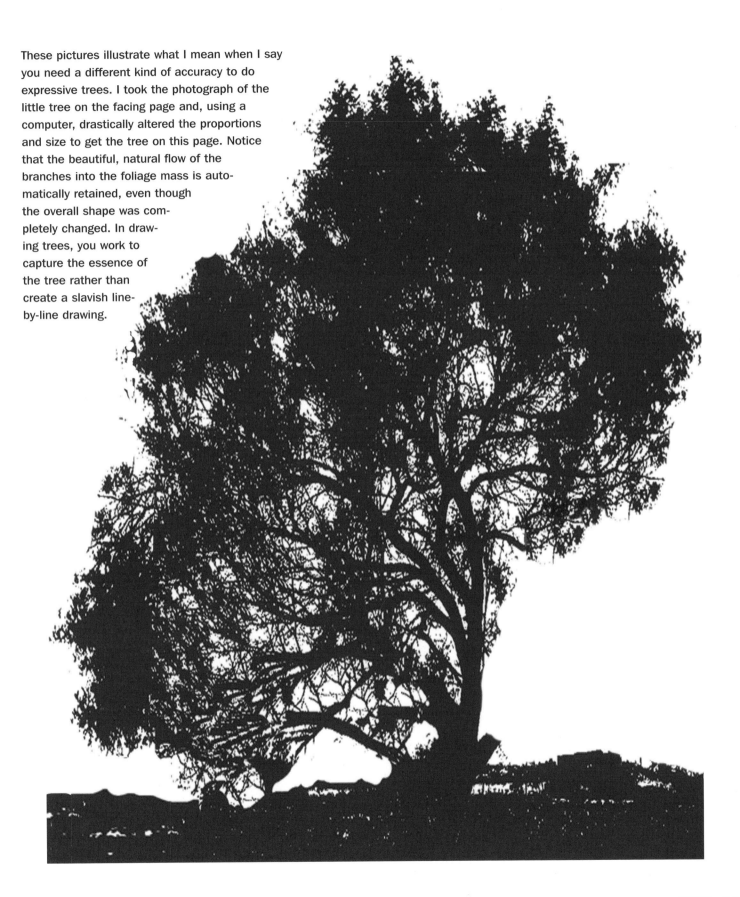

Tree Shapes

For our purposes, we will break a shape down into three stages of development. Although you could start at any stage, think in this way at first, until you develop your own personal way of drawing.

First, capture the big shape. This is the "enveloping" shape, the package that the object is wrapped in, the space it occupies. It is the essence of the thing. I sometimes refer to this shape as the ghost. Drawing this shape is something like lightly stretching a piece of string around the outer edges of an object, skipping over all but the deepest impressions in the silhouette. (Remember, you can see the curves more easily if you straighten segments of them slightly when you draw.) This shape has no detail, yet it has the basic qualities that would identify the object.

Next, draw the contour shape. Work over the first shape, developing the contour. Pay more attention to the character of the object or, when drawing trees, the way the

branches grow. Don't develop anything within the outlines yet; you don't want to compromise the basic shape of the tree.

Finally, draw the developed shape. Work inside the contour shape and refine the outer edges. You may even add some tone to show the separation of light and shadow. This is a tricky stage; you can easily destroy the character of your tree when you go too far. The whole trick here is to keep a strong focus on the overall big shape so that you don't go beyond the point where the tree gets too broken up to keep its identity.

You won't always be following this sequence. You can actually arrive at the developed shape without going through the others, and occasionally, you will work in two stages of development at the same time. But for now, approach your drawings of trees at this time starting with the big shape. It almost guarantees good results.

Again, don't worry about absolute accuracy, although you shouldn't put things down arbitrarily, either. Drawings of trees have a great deal of creative leeway, and are usually better if they are slightly exaggerated. Your drawing should reflect the life in the tree, and you need to be in tune with your subject as you draw.

Tree Gestures

As they grow, trees respond to the light, the wind, the weather, their position relative to other trees, and all the other forces that tend to shape them into their own individual shapes and personalities. I call these tree gestures, because they seem to actually show the life, even the movement and growth, of the tree.

You can always spend a few hours profitably and pleasantly capturing these simple shapes. Just squint at the tree and imagine your pencil flowing around its simple perimeter, ignoring all the little dips and bulges. Try for the essence of the tree. Do the leaf mass and the trunk, either separately or as one shape, depending on how you see it. This is the air that the tree displaces as it pushes its way outward and upward toward the light. It's the big, basic shape. Do not concern yourself with the type of tree you are drawing. Let the model influence your hand. The drawing above is an example of the big shape of the tree.

After you get the basic shape to your satisfaction, go on to the next step. Refine the contour quickly to capture the feeling of growth that you feel in the bigger branches. Do this quickly, without too much thought. Try to feel the branches reaching out to the light, or drooping down toward the ground, or reacting to other forces as they grow.

The drawing below is a move toward the developed stage. It has some simple work inside the contour. These branch masses were handled exactly the same as the outline shape, but they were carried inside it. Note that these inside branch suggestions seem to be growing toward you instead of out to the sides. Also note that I have not lost the big, overall shape of the tree. There are really only three simple shapes inside of the contour.

Without consciously considering it, I have caught the character of my subject, a white pine. I let it talk to me. This is not an accurate drawing of the tree. But it gives us its message as clearly as an exact, tightly rendered copy.

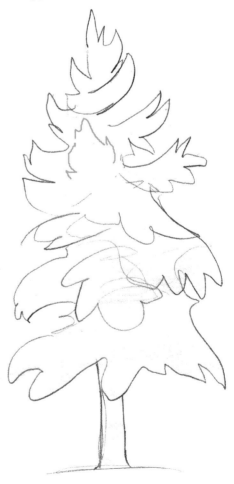

The Character of Trees

The whole character of a tree is revealed in the big shape. The little details are like frosting on a cake: When you add too much, it gets too rich and loses its flavor.

Many trees are shaped more or less like a lollipop, and they do not make interesting subjects. Look for a more promising model—although sometimes, a minor alteration to the big lollipop shape will make an uninspiring tree more appealing.

Here are some approaches to drawing different trees with differing shapes and characters. Before you begin to draw, consider which approach will work best for your subject.

Often the branches and trunk form one simple, big shape. In this case, the branch forms should be developed first. Lightly sketch in the trunk and two or three major limbs, since these major limbs will determine the basic flow of the tree. Then turn your attention to the overall shapes of the leaf masses so that they will integrate with the skeleton and your drawing will preserve the character of the tree.

The crown often suggests an umbrella, with some of the leaf mass coming forward and catching the light from above. The rest of the mass would then be on the back side of the trunk, and you would be looking at the dark, or shadowed, side of the leaf mass. You can emphasize this three-dimensional quality by slightly darkening the leaf masses in the back. Do not overdo the darkening, though; if there is too much, it will break up the whole big shape.

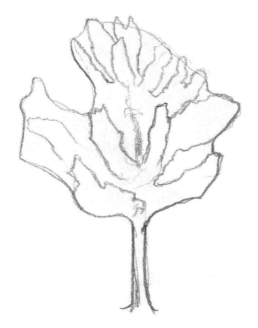

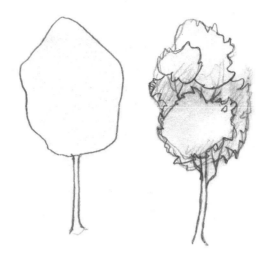

Here's a slightly different approach: Develop the contour first. When you work inside the contour, work on only a few branch shapes, using the same principles as the big contour—that is, put in the big directional shape first, then add character to the contour, and finally, if you must, texture the area to suggest leaves. You will usually find the drawing is better with very little. Notice that the shape of the inside branch forms echo those of the contour, emphasizing the upward-reaching character of this particular tree.

Here is a lollipop tree. I took very slight liberty with the basic big shape. By breaking up the shapes inside the contour into several simple but varying shapes, I was able to add more interest. Then, putting the rest of the leaf mass in shadow lent another touch of interest. I think that this might make an acceptable tree, if it was carried slightly further. Do not break up the masses into more than two or three shapes or your drawing will look spotty and weak.

This was another remarkable tree, loaded with character. It would make a good study all by itself. Notice the excitement in just the simple directional shapes with practically no detail. They tell the whole story of the tree.

Bushes and shrubs can be handled in the same ways. Look for the big shape, then add the leaf masses and some tone to define the specific subject.

Leafing a Tree

How would we apply the shape method to a complex organic shape such as a tree? As you practice, you will discover that after you have gotten the big basic shape the way you want it and established a couple of the major branches, you can carefully consider the full dimensional aspects of the tree without worrying that your thought processes will destroy the aesthetic flow of the drawing.

Masses of leaves offer a unique set of problems to tackle. Trees are often viewed against a bright glowing sky, which breaks through at the edges of the leaf masses and gives them a very distinct character.

When trees are viewed against other trees or background elements, everything tends to blend together to form bigger shapes and patterns. In attempting to capture this texture, you can easily lose the big simple shape and, consequently, the character of the tree.

Here is my approach to handling this situation. The drawing on the left shows the big, simple outlined shape of the tree. I have only outlined one major leaf mass, the one sitting in front of the big shape. I also drew in a few of the major branches, in a single line, so that later, when I added the big leaf mass, I would be able to integrate it with the trunk and branch structure.

In the middle drawing I have added two simple tones to the leaf mass and two darker tones to the trunk and branches.

In the big final drawing on the right, I added a simple symbolic line texture by holding my pencil back farther from the lead and randomly weaving a line throughout the mass while thinking about the leaf pattern. I also lightened and darkened a few areas, being careful not to break up the unity of the big shape.

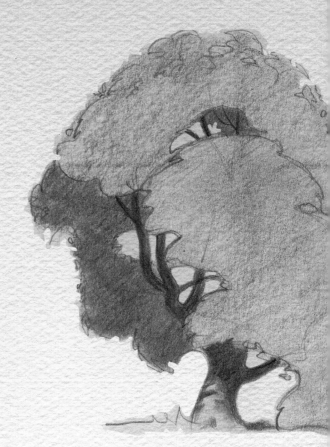

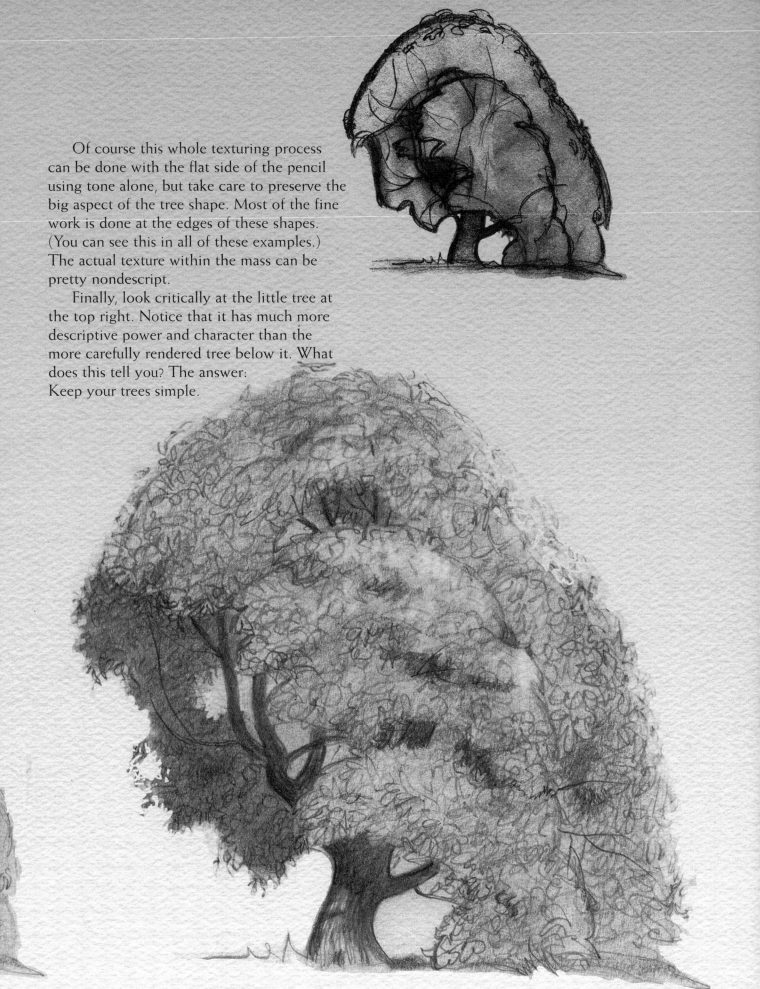

Of course this whole texturing process can be done with the flat side of the pencil using tone alone, but take care to preserve the big aspect of the tree shape. Most of the fine work is done at the edges of these shapes. (You can see this in all of these examples.) The actual texture within the mass can be pretty nondescript.

Finally, look critically at the little tree at the top right. Notice that it has much more descriptive power and character than the more carefully rendered tree below it. What does this tell you? The answer: Keep your trees simple.

Asymmetrical Shapes

Asymmetrical trees are the most interesting trees to draw. No problems with boring lollipop trees here! To get an appreciation of the beauty of tree shapes, go out to the park or woods and draw a couple hundred of these intriguing trees. Look for asymmetrical trees wherever you go; they make the best tree subjects of all.

The top drawing shows the big, simple shape of a deciduous tree. The tree had a wild shape and a dead, lacy branch dangling from the bottom. I drew the shape quickly, with little thought to anything except its overall outline shape. Note the two branches coming out at the same height and angle on either side of the trunk. Normally I would have avoided such a symmetrical layout, but the rest of the tree was so asymmetrical that these even branches became almost a stabilizing factor, so I put them down the way they were.

Before you begin to draw, look at the actual contour of the overall shape. This sketch was developed quickly, but with care to get the feeling of the branch tips reaching out and up for the light, which was quite apparent in this tree.

Leaf masses actually have holes through them and branches weaving throughout. In some trees, the leaf mass is so sparse that everything becomes spotty, but the tree still is contained in an overall shape. In the drawing below, I added a simple tone at the bottom of the leaf mass to boost the solidity of the shape. There is also work inside the contour of this drawing, but it was kept simple and does not break up the big shape that contains it.

Do not carry your first studies any further than this drawing. Remember, you are studying the shape, not trying to render exact leaves and branches.

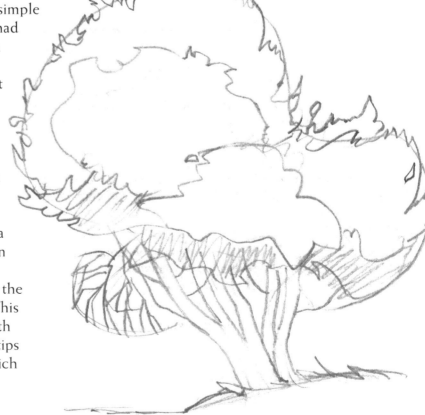

Tree Skeletons

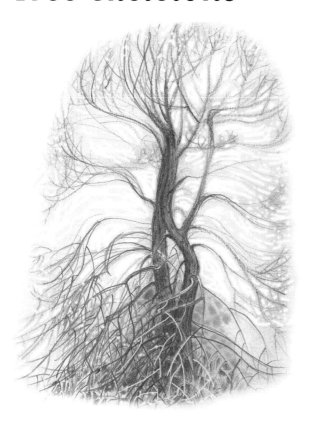

In the winter, when a deciduous tree drops its leaves and reveals its skeletal structure, it can be difficult to see the overall shape. But there still is an enclosing shape around the fine twigs at the tips of the bare branches. You may have to arbitrarily decide the edges in some places, but you can do that if you look for the rhythmic flow of the tree. Drawing a skeletal tree offers special challenges—you must capture the flicker of life in a tree that is apparently dead.

This drawing shows an enclosing shape so well that I chose it from my sketchbook as an example, although it is much too detailed, both for beginning artists and for me. This shape could use some adjustment to get it more interesting. Right now, it looks a bit like a giant thumbprint. It is too literal. This is the kind of drawing you get when you are copying rather than creating!

Note the light tone almost surrounding the whole shape. This light area unifies the drawing and helps the viewer recognize the shape instantly.

This dead tree below showed great possibilities for an interesting shape study; the drawing is a great example of the role shape plays in skeletal trees. These sticklike branches and twisting limbs have a special beauty of their own. Study almost any piece of driftwood to see what I mean. Trunks and limbs have a beautiful rhythm as they twist and reach out to get more light.

I drew this picture, a simple flattened silhouette, with a flexible felt-tipped marker in about a minute. It shows the "shorthand" that I use in my sketchbook to bring back information that I might use later. The original was even smaller than this reproduction, about 1 1/2 inches wide. Notice how I took down only the most basic information—yet I could easily draw this unusual asymmetrical tree at any time with the "notes" I have taken here. Try to develop a working shorthand for yourself—especially if you don't like working outside in cold weather!

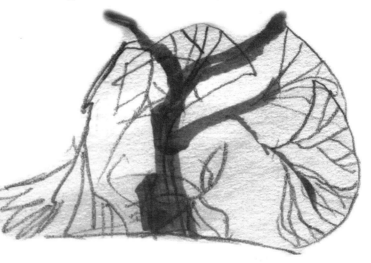

Tree Symbolism

Some watercolorists use a kind of symbolism to suggest the texture of big simple shapes. They will paint the whole area, or shape, with a simple tone, and add details into this tone later. The area, when the viewer looks at it as a whole, suggests (for example) a range of trees, a forest. This symbolism is a very effective way to keep the detail under control in a painting or drawing, and is often more effective than carefully studying and delineating all the little details of a scene.

Actually every artist, no matter how realistically he or she paints, resorts to some kind of symbolism in their work, especially in their quick sketches, which are often more exciting than their finished works. Even Rembrandt used extensive symbolism in many of his landscape sketches. Study his rough, simple landscape drawings and you will see this right away, now that you are looking for it.

These examples are only a few of the symbols that you can use. Invent your own, following actual scenes for authenticity. My examples have been done with simple pencil lines, but you can use a brush and watercolors very effectively as well. The main point is that these lines and tones are added only to identify and add interest to a larger shape, and should be used with restraint. Usually the less, the better.

Most of the drawings in this chapter were made in one of my little five-by-seven-inch sketchbooks. All were drawn in pencil. This is the medium you can easily carry with you into the field; and it is inexpensive, so you will use it more than anything else.

In the near future, though, make it a point to try broader mediums, especially a brush with simple black watercolor. Often a sponge or brush with the tip cut off can be used to suggest leaf masses. It is a great way to study tree shapes, and you can get some very expres-

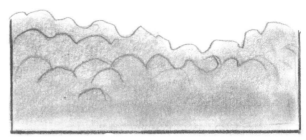
The curved lines suggest deciduous trees.

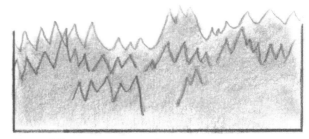
Jagged lines suggest conifers.

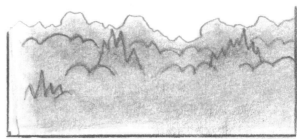
This picture shows a forest with both deciduous trees and evergreens.

Trees or brush along a highway or river would look like this. Notice how the edges of the trees in the foreground overlap the road a bit.

sive results with it. If you can use a light to middle value paper, so much the better, because then you can use white paint to finish off some of the branching that comes in front of the darker masses of twigs and branches.

Conclusions About Trees

When drawing trees, remember that the more you know about your subject, the more convincing your sketches will be. Every tree has a root system spreading under the ground that approximates the size of the branch spread of the tree, and you can usually sense the presence of the roots by the slight flare of the trunk where it meets the ground.

Study the basic big shapes of different species of trees, as well as the way these trees branch out and react to the things around them. How does an oak grow? How does a maple grow? How about a Norway spruce? Illustrated handbooks of trees can also give you some useful information on identifying trees and their basic shapes.

Remember as you work that the branches reach out in all directions, not just sideways. They also come toward you and away from you. Even in silhouette these directions must be noted.

The thing that makes seeing trees in these simple terms so hard is the fact that they are not solid objects. They are lacy, sometimes spotty masses of individual leaves. The edges of the leaf masses are always soft or blurred because they are partly solid and partly light, with sunlight filtering through and between tiny solid spots. Because of this, when two or more trees are growing one in front of the other, they blend together into one single shape. Only when the light hits them at the proper angle can you separate them visually, and even then, only part of the individual tree or branch can be seen.

The only way to draw trees successfully is to draw hundreds of them—not developed trees, with complicated textured areas of leaves and bark such as those you see in many books on tree drawing, but big shape drawings. Get to know trees, and they will reveal their secrets to you.

You can texture clumps, or even whole fields, by selecting the proper symbol and breaking the edges of the shape with it.

Use this kind of symbolic tree to indicate a tree growing on a rocky cliff or in headlands.

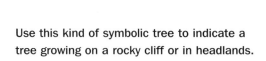

The same technique works with rock piles, even if there are no plants growing there.

Even trunks and driftwood can be represented with a symbolic rendering.

6 Shapes in the Landscape

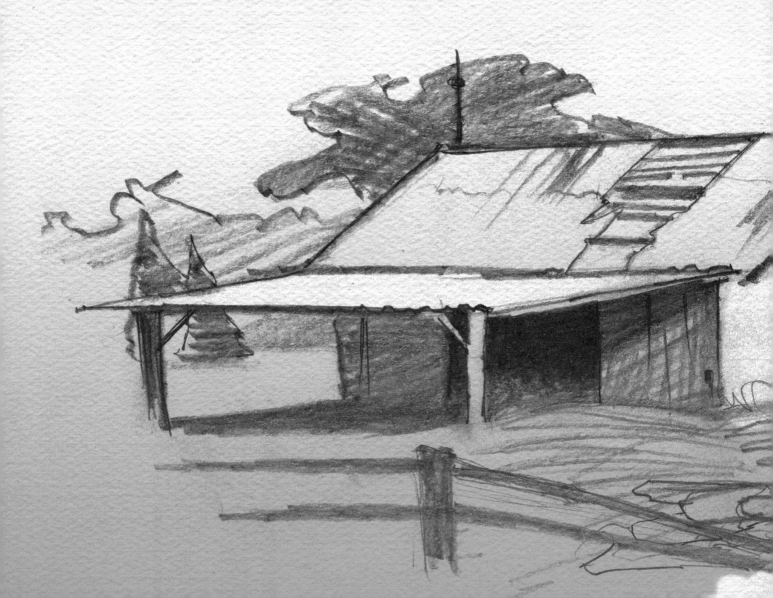

Landscapes can be overwhelming at first glance—but, in reality, they are far less complicated than they appear. Learn to see the basic shapes in any landscape, and to convey them simply and clearly in your drawings.

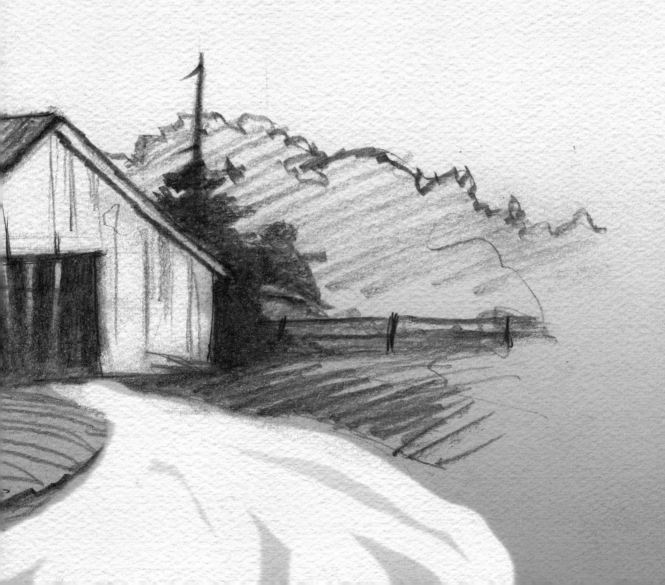

Capturing Landscapes

A landscape can be overwhelming. So many shapes! So many textures and colors and forms! Where do you start?

The landscape seems to be far more complicated than it actually is. Let's start by thinking of it as nothing more than a series of planes that are either horizontal, vertical, or at an angle. Think back to that crumpled sheet of paper we drew earlier. The difference now is that you would be the size of an ant standing on the piece of paper. (In some cases, a piece of cloth would give a better picture, because it takes curving, or rolling forms as well.)

When you break down the shapes of the landscape into two types, those that reflect the light and those that give the light (usually the sky shapes), you start to understand how the light creates the forms of the landscape—and you will get a quality of light in your work that might elude you otherwise.

The sky is everywhere. When you stand outdoors, you are standing in it; you see through it because it is usually clear, but it still affects everything you see. There is always some sky between you and the objects you are viewing, but it takes distance to really see the effect it has on things.

Think of the sky shapes as areas of limitless depth that always sit way back, behind the farthest of your solid land forms, and often suffuse the other forms with their glowing light, affecting their values, edges, and colors. Think back to the island that I talked about in the beginning of the book. Remember how the scene progressed from almost total blackness, to a soft black band across the landscape, and finally became a textured mass of trees on an island silhouetted against the far shore? It was actually the changing sky that so strongly affected the landscape shapes.

Land shapes or forms can present themselves to you at any angle. Learn to see whole areas as simple shapes, and determine their general orientation. Enormous mountains that are made up of many different facets and features, including trees, still have dominant directions to their overall shapes. Prairies can be rolling or perfectly flat; you need to sense that feeling and capture it in your work. Distant groups of trees and bushes go a long way toward explaining the shape of the land forms they sit on. Shadows lie on the land like a rug and also broadcast the underlying shape of the ground beneath them.

Your eyes can probe into the darkest corners of a landscape—but that skill can get you into trouble if you don't compensate for it and simplify your value scheme to one that can be drawn and understood. To do this, simplify the scene into four or five basic shapes. Often they will be the foreground, background, and one or two middle-ground shapes. Since there are no outlines around nature's shapes, you have to assign a value to each one in order to separate them from one another. This immediately establishes the mood of the drawing, and you must work within approximately two values in each of these areas or shapes as you render them, or you will lose the mood. For example, if you have four big basic shapes, and use two values for each, you would have used up your whole value range, with one darkest and one lightest value left over for final accents. So you could easily end up with a confusing mass of values, rather than a clear, easily read picture.

There will be times when you might have only two or three basic values in the whole piece. This is called a key, or value, chord and requires very careful rendering. There will also be times when a busier overall pattern is more appropriate for your drawing, like a piece of wallpaper. But most good paintings or drawings consist of three or four big shapes, separated from one another by simple value differences.

Line can give you more latitude in your design, helping you to define or merge shapes. You can often come up with more unique effects by massing big areas together, as I demonstrate in my drawing here.

When you learn to reduce the complexities of a landscape down to big simple shapes, you really begin to appreciate the unbelievable diversity of vision among artists.

Simplifying Complex Scenes

This is a perfect example of being confronted with too much detail to make a good picture. It presents a very complex rendering problem—much too complicated to copy everything exactly. The tangled mess of branches, twigs, and rubbish piled up over a creek gave me so much to focus on that I had to be very selective about what I chose to put in and how I handled it.

To simplify my drawing, I let my line work represent the bulk of the detail, and I pulled it all together with a simple, flat gray tone. I left only two simple main shapes

outside the wash, bracketing the little Styrofoam cup as my main focal area. Actually, the cup is the real focal point; it was a very disturbing element among all these beautiful natural forms.

Note the simple shapes; they are left practically in their flat pattern state in this drawing. These natural shapes almost do the designing for you as you work from them. The negative shapes between the branches are just as interesting as the shapes of the solid objects.

This was my original sketch.

Two simple main shapes bracket the cup, creating a focal area.

Simplifying Values in a Landscape

Photographs make it easier to see how to simplify values in a landscape. Drawings, filtered through the impressions of another artist, can be less instructive.

Let's look at this black-and-white photograph of a fairly standard landscape scene. Using a computer, I reduced this picture to three values: black, white, and a middle gray, to produce the second picture.

In the plain photograph, the sky shapes are the lightest areas in the picture, as is often the case; the sky is usually the light source. The road is almost the same value, because it is made of a very light-colored material. But since it is reflecting the light, it cannot match the brilliance of the light source. The metal roof reflects more light than the shingled roof area and is slightly lighter, about the same as the road.

The grassy area is next going down the scale of values. It is lighter than the trees because it is at right angles to the light source. The tree shapes are darker, because they are angled to the light. They also have big shadowed areas.

The strongest darks in this picture are found in the deeply shadowed areas, such as windows and doors, the area under the eaves, and the big tree in the foreground. All of these areas are actually quite similar in value. All of them would fall in the mid-value range. Their positions relative to the light source strongly affects their values in a scene.

The modified view is more abstract, and the shapes become very apparent. Now the light areas of the trees in the background and the grass, as well as the sides of the cabin, all mass together into one simple middle value.

The sky and the road, along with the main mass of the roof, are the same white value.

The rest of the shapes are all massed into black. Notice that this black carries the bulk of the identifiable detail in the picture.

If you were doing a painting of this scene, you could start by washing in three values of color; and by working within a range of one or two tones within each area, you would get a creditable picture. But if you added too many additional tones within each of these areas, you would break them up to the point where they would lose their distinction from each other, and you would end up with mush. This is what is meant by organizing your values. It is really the basic structure of your work. Everything else—design, brilliant draftsmanship, exciting color, dazzling technique—all will sputter like a wet firecracker if the values don't do their job.

Don't take this as a limit on your creativity. There are no laws saying you can't move the road, or a tree, or change the size of anything you want within the picture. You can rearrange the values, flatten things, emphasize or subordinate them almost any way you can think of to make an exciting picture. The one thing you cannot do is make mush out of your values and get anything worthwhile out of your efforts.

Divide shapes into those that give light and those that receive it.

Look at the original photograph. Do you see that it is really nothing but flat shapes— but the values make it practically impossible to think of them that way? It's a little easier to see the flat shapes in the bottom picture because of its simplification. Think of the creative possibilities that this concept opens up. Why would anyone want to simply copy something when focusing on shapes offers so many exciting alternatives?

Modifying Your Pictures

Now let's look at drawing. Remember: You have total freedom to organize a drawing in your own way. You use what nature has to offer you; you are not restricted by it. Just use it logically.

I drew the shack that is shown in the photographs on the previous pages. The first drawing was made several months before the photos were taken, drawn in bright sunlight in just a few minutes, using three markers, a black one and two grays.

Later, after spending an evening under a big, beautiful October moon, I quickly worked over the sketch with different values to see if I could capture the effect of the moonlight. The difference in feeling was astounding. By massing the dark areas into simple bigger shapes and adjusting the value of the sky, I got a very convincing moonlit landscape in the second picture. It is surprising how close this drawing comes to the photograph that was reduced to simple black-and-white, since it was made long before the photograph.

Markers are not necessary for you to study drawing. Once you have made a line with a marker, you cannot go back and change it. But they are a great learning tool. If you keep loose and free in your sketches, a set of two grays and a black marker with fine tips would be a great addition to your kit at this point. Markers force you to think in big, simple flat values. You can always work over a sketch, as I did here, if you go darker, but it is difficult to lighten things up.

However, you should be working so free and loose that you won't mind doing things over if you goof up the first time. Sometimes I will do a drawing four or five times if it seems I need to. After all, these sketches only take minutes to do.

I used markers in three values to draw the shack.

By adding more dark values with a marker, I got a convincing moonlit landscape.

Cropping and Changing Values

Here's our shack again. This time, I wanted to add just a tiny bit of creative consideration to the picture. So I have cropped it way down to simplify the shapes even more. We are still basically using things the way they came to us, but by simply cropping the photograph, we get a totally different effect.

Here is the cropped picture, reduced down to simple black-and-white. The shapes have become very apparent now. See how the black shape explains what is happening here, even though it has swallowed up most of the detail in the gray areas? Now it makes a much more interesting design. All that detail that seemed so important in the top picture does not seem so critical anymore.

Now I have added a simple gray, a transitional value that brings back some of the detail. Again, if you were painting or making a finished drawing of this scene, it would take very minor additions of value within each of the shapes to create a good picture. Note the interesting edges of the shapes, and the textural patterns. These are very difficult to draw, unless you use a rough paper or other means to keep them from looking too regular or contrived.

Natural Textures

The first example we considered in this chapter had both human-made shapes (such as the shack) and organic shapes (such as the trees). Now let's take a close-up look at pure organic shapes.

The top picture is of a section of a rocky path. If you want to get frustrated, try to draw it with the random beauty that nature builds into all of her forms. The hand and mind of humans are too organized and too unsubtle to capture it. Most artists are smart enough not to even try. They let nature do the hard part for them by using nature's materials, such as sponges dipped in paint or gravity as they splatter the paint onto the paper, and then they accept the random patterns they get as a simulation of nature. An artist might then add simple touches or clues to finish the effect, but he or she would never try to copy this kind of effect slavishly.

There are many ways to arrive at these beautiful textural effects, patterns, and shapes. Most of them lend themselves to painting and other "wet" mediums, but you can get them with drawing mediums, too (although you might have to resort to solvents when you use graphite). Experiment with this.

The bottom picture is the top picture reduced to pure black-and-white. I added a very few clues into it to help suggest the rocks better, but even there, you can see the tampering when you look for it.

The moral here is: Don't try to copy nature's effects— suggest them.

Natural Shapes

Nature's patterns are everywhere. Here are a few more examples, using photographs to illustrate them. Learn to look at these patterns and understand natural design. What does the surface of a river look like? How do leaves on a tree look when they are being blown by the wind? How does ice on a puddle form? Discover the art of nature everywhere; it will improve your own art.

This photo is an example of utter simplicity. A simple, flat sky shape. A simple, flat field shape. The dark shape across the horizon does all the work: It explains the flatness of the field, and by its edges, the dark shape shows that it is made up of trees and brush. The dark leaf mass establishes that there is a tree in the foreground, and the dark mass hugging the left margin pulls you back into the picture.

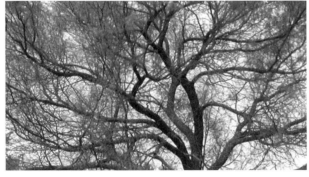

Like a giant jigsaw puzzle, the beautiful pattern of the sky shapes between curving branches make an almost abstract composition. The brilliant light from the sky shapes lightens the translucent leaf masses and softens the whole effect.

When the sky darkens, the land darkens correspondingly. If the dark shapes in the foreground of this photograph were lighter, the whole effect would be lost. Notice the difference in feeling in all of these pictures between the sky shapes and the land shapes. The sky in all of them is lighter. The exceptions would be sunlit patches, areas that catch the sunlight strongly, especially if the sun is outside the picture limits. Then the picture will have a completely different quality.

How do you know what this picture is? This is a good example of a lack of focus and weak value organization. You can still tell what this picture is, but it is difficult, and the picture gives you an uneasy feeling. There are no clear, simple recognizable shapes, and few clues as to what you are looking at. Hold this page at arm's length so you can see all the pictures at once. Can you see the difference that the organization of shapes makes?

Using Your Sketchbook

Your head and your hands are your main tools when you set out to draw landscapes. Learn to look and to see. When you are ready to capture what you have seen, your big workhorses will be your pencil and a small sketchbook.

Keep your shapes and values simple. You will only get frustrated and discouraged if you try to copy nature. This is the time to simplify. Look for shapes, and look for values that can be massed together into big simple, flat shapes. State what you see simply and confidently, and don't worry about creating masterpieces.

> *Shapes alone tell the viewer what they are. You don't need to add a lot of detail to the outline of a mountain.*

The sketches on these two pages show how you should be working at this point. Whole masses of mountains, trees, or rocks should be lumped together into simple shapes of a relatively flat value. Even buildings can be made to merge into interesting shapes to keep things from getting too fussy in your sketches. The edges of these shapes go a long way toward explaining what they are; you don't need to provide a lot of clues inside them. Let the viewers furnish their own details; they will enjoy your work more.

Earlier in this chapter, I asked you to visualize the orientation of your big landscape shapes. There is no mystery about this; it is simply getting the sense of the direction of the way the planes are facing. You can do this with lines, or with tones suggesting shadows, or with simple changes in the growth patterns in big flat masses, such as fields. In the two drawings on the facing page, the simple lines in the foregrounds leave little doubt of the orientation of the land they represent.

Even an odd-shaped mountain still looks like a mountain.

Strong shapes convey the feel of this little village.

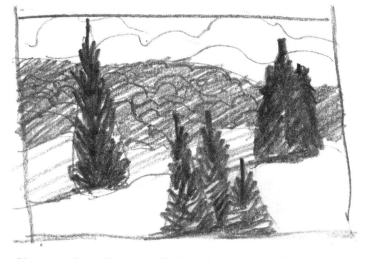

Pine trees have their own distinct shape; you don't need to show every needle.

Landscape Inspirations

It would be ideal to do all your sketching directly from nature, but we have to take our inspirations where we find them. The modern world is loaded with material for study: newspapers, magazines, videos, books, art galleries, the Internet. There certainly is no lack of stimulation out there. As long as you concentrate on seeing and arranging the shapes of your subjects, you stand little chance of falling into the habit of copying things.

Keeping your sketches loose and free like the sketches on these pages will also push your mind in the right direction.

Occasionally work from your little roughs. Try to rearrange the shapes into better compositions, or changing

Many landscapes are oriented horizontally.

Other landscapes have a diagonal orientation.

the value arrangement to suggest different lighting conditions as I did with the little moonlight scene.

Try pulling the eye around through the sketch by softening some edges between shapes. That will let the viewer's eye flow more easily into the adjoining shape. Add little clues in areas that seem to need more explaining. Just be careful not to get so many different values into the shapes that they begin to lose their identity and look like masses of instant pudding. Let your pencil strokes and your thinking processes show through; after all, that's what makes you different from the next artist. You lose your own identity when you slavishly copy another work of art.

A house, a tree, a cliff, a shed, a mountain in the distance . . . these are some of the defining shapes in a landscape.

Take Control

My big point in this chapter is this: You will get much more control of your landscapes if you simply take charge and reduce the elements to a few simple flattened shapes, at least in the planning stage.

Landscapes should be groupings of strong, simple shapes. Avoid fussy details.

The sketches on these two pages show how you can simplify a landscape down to three or four values and get dramatically different effects from the same grouping. Buildings can sometimes be massed together to form one big shape; trees and bushes should also be shown as big overall shapes

of a flattened value and grouped to make bigger, simpler shapes. Note that there are no doors, no windows, no other details.

There is no fussy drawing anywhere in these drawings; anyone could do them. This kind of simple thinking takes the work out of drawing and painting and makes them a joy. You can always noodle around to your heart's content after you have this simple, clear-cut plan, but you will find that you don't need as much of that labor as you think.

Even if you want to do super-realistic landscapes, approach them with the idea that you need to start out with—and end up with—clear, easy-to-read shapes. This outlook will give you much more confidence and control in your landscape work.

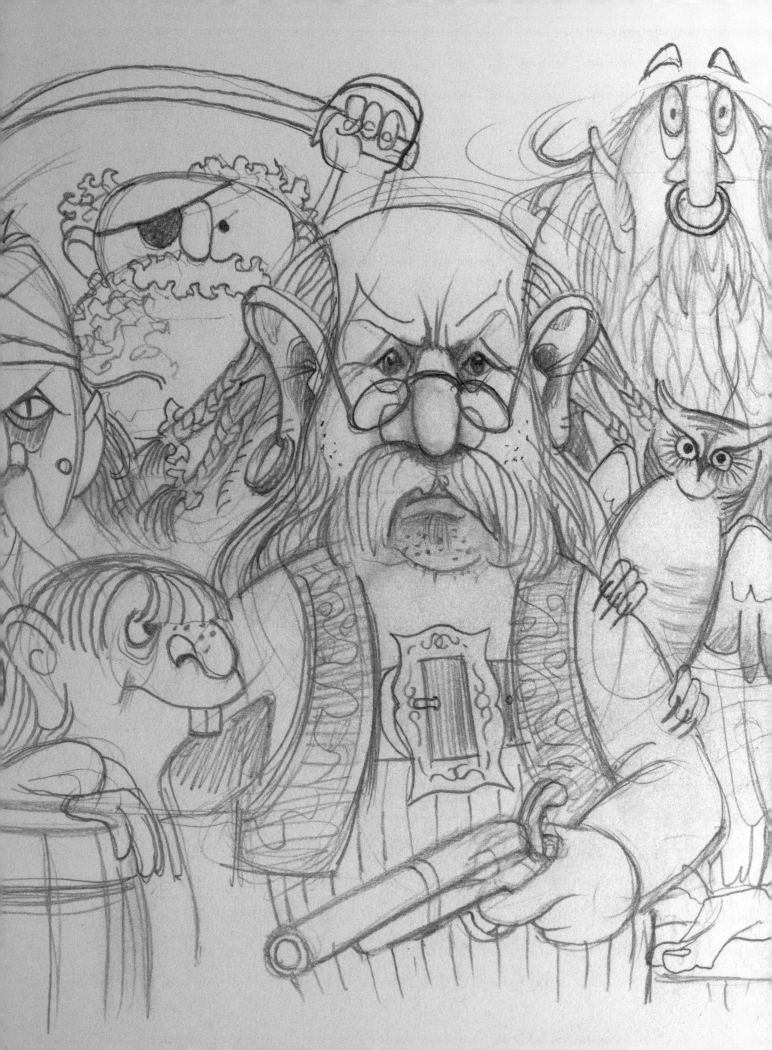

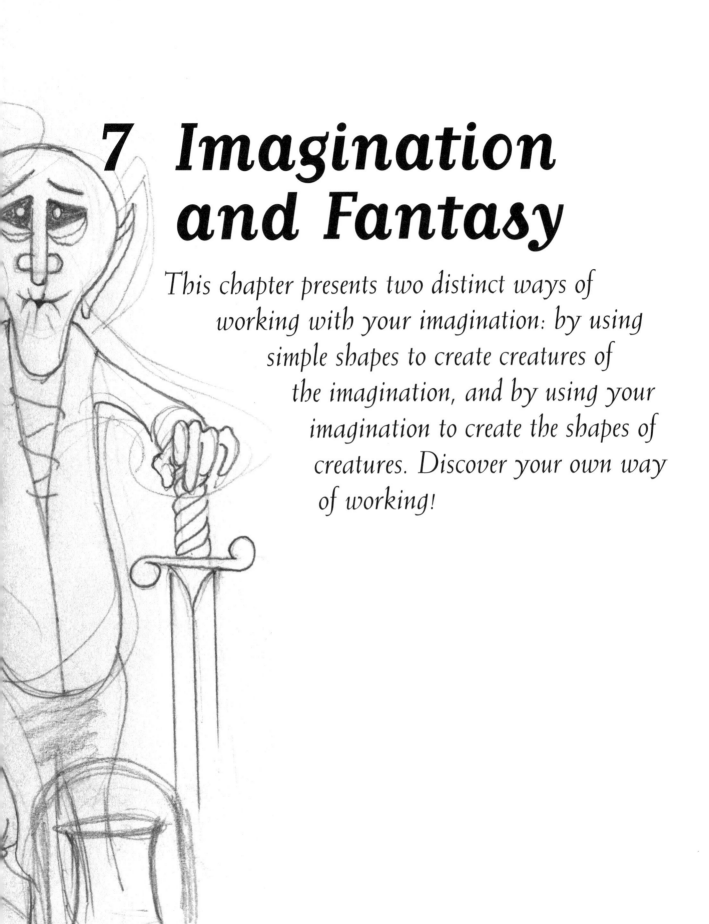

7 Imagination and Fantasy

This chapter presents two distinct ways of working with your imagination: by using simple shapes to create creatures of the imagination, and by using your imagination to create the shapes of creatures. Discover your own way of working!

Fun with Shapes

Up to this point, I have been explaining to you—and you have been training yourself—to observe and draw the shapes of things you see around you. In this chapter, we are going beyond mere copying . . . into the world of imagination. If there really is something in the art of drawing that cannot be taught, we will find it here.

Now we are going to create shapes that trigger the imagination. When you work without a model, you have little to judge your results against. So you must trust your own ability to visualize.

Think of it like this: When you look at a drawing by someone else, you know instantly if there is something you don't like about it. Learn to look at your own work in the same way.

It is more difficult to judge your work while you are actually doing it, but that problem should be considerably lessened if you have been thinking in shapes and comparing them as you draw. Look dispassionately at your work in progress. If it does not look right, study the big shapes; they generally contain the problem. Fix mistakes the minute you recognize them. You'll simply compound your errors if you put it off.

You can be sure of one thing: If you can tell that something is wrong later, you can also learn to tell when it's wrong while you are doing it. You know when something is right.

Discover the power of
your own artistic imagination.

When you pull something out of your imagination, no one else can judge it for you. Another person can tell you if he or she likes it or not, but only you know if it's actually what you want. This freedom is your passport to the creative world. You will need to use it with taste.

Of course you will still make plenty of bloopers; everyone does. Even Rembrandt did his share of less-than-great drawings. But you will never draw creatively, or freely, until you drop the timidity and begin to feel confident that your hand will do exactly what you want it to. Drawing comes from the brain, not the hand.

We are now going to work without a model in front of us. You are going to have to draw from the pool of experiences and knowledge that you already have in you. Are you ready? Let's find out.

Drawing from Imagination

Early in the book, I talked about cloud formations, and how, as children, we all got so much pleasure from gazing up at fleecy clouds and imagining different creatures in their shifting shapes.

Drawing in shapes is essentially the same process. But now you have some control of the initial images. You don't need to wait for nature to give you a shape that reminds you of something.

You now have two options. You can put down a shape that approximates the thing you want to draw, and then you can develop that shape. Or you can doodle abstract shapes until they spark your creative imagination and develop your drawing as things suggest themselves to you.

Some artists carry this approach further, making splashes of color or textured shapes from various objects such as sponges or wrinkled paper dipped in paint—anything to form interesting shapes to work with. Some artists never carry these creations to the point that they represent anything tangible; they simply develop an interesting design and work abstractly.

Remember, imagination is the womb of every new movement or style in the world of art, from cartoons to fine art. In the end, they are all products of the same process that you enjoyed so much as a child looking skyward. Let's try to recapture some of that childlike wonder.

Cartoons

Some cartoonists could be the finest of the fine artists. Their work is the epitome of saying the most with the least.

The use of simple, almost geometric shapes by cartoonists is well known. The drawings in this chapter are much in the style of cartoons, and as you read this

Artists don't have to be serious all the time.

chapter and practice the exercises, study the simple basic shape combinations.

I enjoy doing cartoons, and did them for advertising work for many years; but my basic style of drawing leans more toward realism, and that is the main thrust of this book. After this chapter, we will return to realism. But you may be surprised by your own response to stylized approaches. If you find you have an interest, start paying more attention to good abstract work, and also to the art or books by others that work the way you see things.

An Exercise

Start doodling. Draw shapes and turn them into animals, birds, houses, patterns, cartoons, roads, trees, bananas, whatever.

Try a game that children sometimes play: Ask another person to make a mark on a sheet of paper—a squiggle, a wiggle, a circle, a square with a line running through it, anything your partner likes. Now take the paper and turn that squiggle into something. This is a great way to develop your creativity. As you play, try to think "outside the box." Don't just make that circle into a smiley face. Turn it into a round cow, a monster with horns, a fish's eye. You can pleasantly while away some time with this game as you develop your imagination.

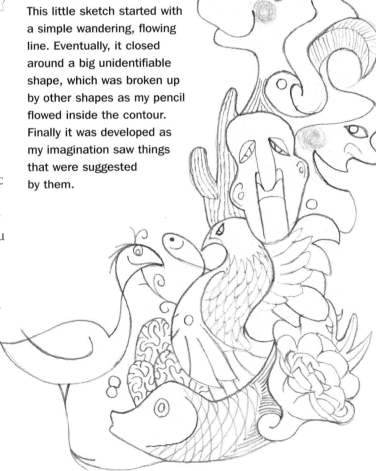

This little sketch started with a simple wandering, flowing line. Eventually, it closed around a big unidentifiable shape, which was broken up by other shapes as my pencil flowed inside the contour. Finally it was developed as my imagination saw things that were suggested by them.

Creative Distortion

Look at the shapes in the drawing on page 121. They are certainly not the accurate shapes that you were trying to draw in the early pages of this book. Some of the shapes in the doodle really required me to stretch my imagination in order to see the things they suggested—and they demanded the same of you, as the viewer.

Yet these shapes still communicate with us as clearly as these words do. As long as the shape even remotely suggests something, it can be developed to any degree that your creative inclinations dictate. In many cases, the result will be a much more powerful and dramatic statement than it would have been if it were totally accurate.

The degree of distortion of the basic shape from the actual subject you are looking at (or imagining) is entirely up to you.

Some readers probably have no interest in anything but drawing as realistically as possible, and they will continue trying to draw exactly what they see. In this chapter, though, I am giving you a way to check yourself and to expand your vision.

A drawing or painting is nothing more than marks on paper describing things that are three-dimensional. It can never be anything more than symbolic, no matter how you do it. The only difference between one style and another is simply the degree of distortion or manipulation of the shapes that contain your subject. Distortion is simply another powerful tool in the creative artist's kit. We all use it, consciously or unconsciously, to a greater or lesser degree.

Cartoonists and caricaturists are good examples of the creative use of intentionally distorted shapes. The cartoonist reduces the shape to its simplest, almost geometric state, and the caricaturist exaggerates important features and subordinates others.

The illustrator who does imaginative things for children's books or "realistic" science-fiction scenes of dragons, demons, or make-believe landscapes relies heavily on distorted shapes for his or her creations.

When working creatively with shapes, you have the option of keeping the image flat or using all the knowledge at your disposal to

turn the shapes into believable solid forms. This is where your personal taste enters the picture, where new styles begin, and where creativity is given full rein.

An Exercise

Everyone is a doodler. Even those who do not think of themselves as artists will often start scratching on anything available if there is a pencil handy during a phone call or at some other downtime.

Try this exercise: Grip your pencil back farther from the point than you usually do and lightly pull a line around randomly until you get a flowing mass of lines and shapes. Keep your line lighter than mine, just dark enough to see it clearly. Don't think of anything specific as you draw, just let your pencil ramble haphazardly around. Fill in your paper, making little shapes and patterns without too much concentration.

Now stare at your pattern and let your mind wander. If you got enough variety in your shapes, they should begin to suggest things to you. Can you "pull out" some of

these images? Develop a couple of them as I did in the drawing below. Don't get too fancy; just darken the lines that describe your vision, and maybe add a simple flat tone here and there to clarify things. You can add an extra line when you need to finish off the image, or maybe other marks, spots, or textures; but try to use mostly the existing lines.

I got lucky on this drawing and the shapes practically jumped out at me, but you might be experiencing a little trouble seeing images in your scribbles. This is probably because there is not enough variety in your shapes. You may need to experiment for a while, but keep working; this exercise pays big dividends in the development of your imaginative powers. When you have done this a few times, you might try it while thinking about a specific subject, and draw the first shape that comes to mind.

Realize that your mind has the power to take even highly distorted shapes and turn them into recognizable objects. Your brain actively searches this jumble of lines for shapes that it can play with. When it finds something even vaguely sugges- tive, it will guide you by suggesting the clues it needs to fin- ish the image.

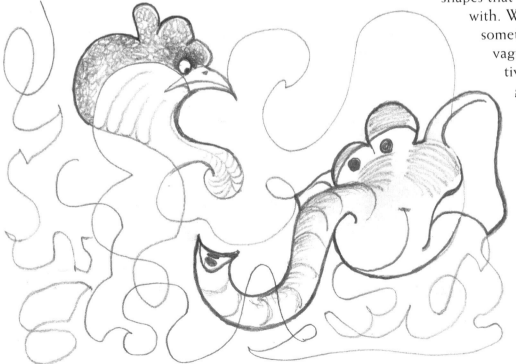

Test Yourself

We think of some people as imaginative and others as unimaginative. Exactly what does this mean? What is imagination?

The word "imagination" can have many meanings if you look for it in the dictionary. Here are a few: "The act or power of forming mental images of what is not actually present." "The act or power of forming mental images of what has never been actually experienced, or of creating new images or ideas by combining previous experiences." There is more, but we can stop right here. That gives us what we need to work with.

Consider these definitions. Could you form an image of something you have never seen or experienced? I'm sure you can. What do you base it on? It seems obvious that, since your well of experiences and images was empty when you started out in this life, you must have accumulated them as you went along.

We all have our own wells of information stored somewhere that we can draw on when we need it. As with every other skill in this book, it takes effort and concentration to learn to fill the well and use its water. Yes, it is true as always: Some people do these things naturally and easily; others find it practically impossible. Let's see what you have in your well of experiences and images.

An Exercise

Stop looking at the pictures here now and focus on reading the exercise instructions. Set the book aside before you start on the exercise.

Simply draw the outlined shape of the image that comes to mind for each of these things: a fish, a bird, a snail, a pig, a snake, and a flower. Do each shape quickly and simply; you can put in the minimum of details if you like. Just draw basically what you know about each shape. Then let's take a look at your results.

How deep was your well? Most of you undoubtedly had at least one of those subjects that interests you, and you did the best on that. If I were to have added a baseball or football theme to the list, most of you would have done well with that—the shapes are very clearly defined, and many people are interested in the sports.

We can safely say that in order for images to get into your well, you need to be interested in the object, or at least concentrate on it. But here is the big thing that I have noticed with this exercise. If you have drawn or sketched anything, it gets into your well, and it stays there, ready to be pulled out, for a long, long time. The harder and longer you concentrate on an object as you draw it, the stronger the remaining impression becomes.

The things that I had drawn before were easy to draw from imagination, even though I changed them. Actually, I could have drawn the bird, the fish, the flower, and the pig much more convincingly, because I have drawn them many times before. But I very rarely draw snakes and snails, so those drawings are more abstract. In short, I had little or no recall of anything that I had only read about or even actually seen—but if I had drawn it, I could easily bring the shapes up in my mind again.

The moral: Get interested in everything. Concentrate on the shapes of the things you look at, and draw or sketch them. That's how you fill your well.

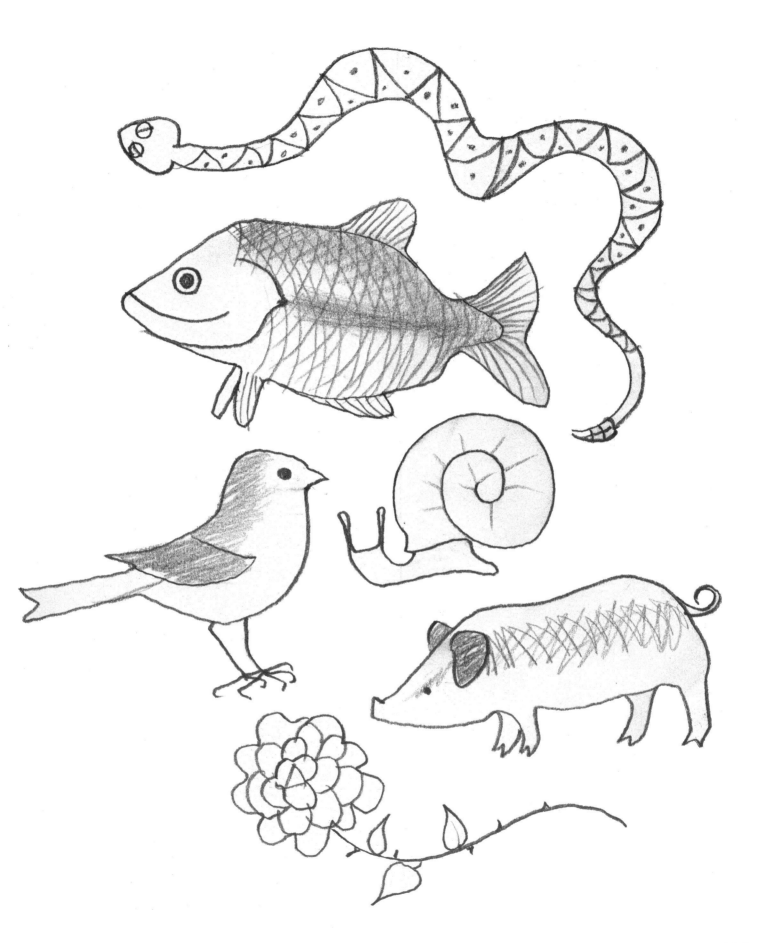

In the Round

Imagine a sculptor as he starts his work with a shapeless mass of clay.

At first, the clay is nothing more than a slab, waiting for the sculptor's hand to turn it into something meaningful. It could be compared to an artist's blank canvas or a first line on a piece of paper from a sketchbook.

The sculptor builds the raw clay into a crude form that approximates the subject he is modeling. Little by little, he adds new blobs of clay where it is needed, and removes excess clay from areas that were too full. All the while, he is carefully comparing his creation to a model in front of him or to some vision he has of what the finished piece should look like.

Sometimes feeling his way along, he continues adding and removing clay until he is satisfied with the basic forms—the shapes—of his creation. Only then does he begin the process of finishing the surface of the clay. He is never too concerned about making changes in these early stages, because they are easy to do and can always be modified more if needed.

If he had started putting in careful details right away, such as eyes or fingers, it would be much harder to change them, because he would be reluctant to destroy all the work that it took to do them. He would be much more tempted to leave things alone, even if they were found to be wrong. It also gets harder to see basic mistakes after the details have been placed, so he might miss them altogether.

You can get much from this approach by thinking of your drawing as a lump of clay.

You can get your first big shape down by taking a hard, quick look at the thing you are drawing with the attitude that it might disappear while you are looking at it. So you quickly draw in the basic shape of the air that your subject displaced while it was still visible. This is your "ghost." It is the first malleable shape, which only suggests your subject.

Now you can begin the process of adding, and removing, just like the sculptor did. The secret to working this way is to keep all your initial searching lines or tones light enough so you can actually leave them in if you want. You will find that this early exploratory work actually enhances the finished drawing if it isn't too strong.

An Exercise

Think about a bear. You can look at a photograph, or you can imagine what one looks like. Just quickly sketch in a shape that reminds you of a bear, keeping it very simple, with absolutely no details. Don't try to make it accurate or perfectly proportioned, just get it so it has the essence of a bear.

Look at your shape and try to see it as a solid lump of clay.

Now put in a few details to make your bear look more solid. Notice in the second sketch how, with a few simple lines, I added a leg and pushed one leg in front of the other on both front and back legs. I also added a couple of ears, one sitting on the back side of the head in a position that amplifies the solidity of the head. The same is true of the eyes. Also note that the mouth (even an unrealistic mouth like this) sits on a curve that fits around a solid head. Finally the nose is added to reinforce the conelike shape of the head.

Now make your bear a solid presence, three dimensional and "real." In my last picture of the bear, I used the simplest kind of sculptural modeling to add the final touches to the illusion of solidity. I pushed back areas with darker tones, keeping their edges soft, in this case, to round out the forms. I also stroked the surface with a few light lines to lead the viewer's eye around and over it.

If you are having trouble with any of this, go back to Chapter 3, "Adding the Third Dimension," and practice drawing geometric figures with depth until you have a good sense of the solid surface of simple subjects. You should be able to sense the difference between thinking in flat shapes and thinking of them as solid by now.

We have entered the area of drawing where most perceptual problems begin. Your brain's left half tries to take over and tell you what it knows about your subject. Control it now, or you will get all kinds of distortion in your work. Back up to look at your drawings a little more often. Keep trying to see the whole drawing while you work; don't focus down on the details too early.

Adding Form and Texture

Now we are going to use many of the things we have learned so far about using flat shapes first, then rendering them into solid shapes. We'll even look at adding textures to the surface of things.

There are three drawings on these two pages. They are reproductions of the actual stages I drew as I progressed. The drawing on the right is the actual size that I worked, and it is fully developed at the head only; the rest of it was left in various stages of finish so we can discuss them.

The drawing was done purely from imagination in a couple of hours. I purposely used a simple, rather unimaginative side view here; but as you develop, you should be able to imagine your subjects in any conceivable position.

In order to draw from your imagination, you have to have material in your head to start with. This is where your well of experiences, studies, and observation habits will show themselves. You cannot draw water from an empty well. However, you can take one shortcut: You can always use reference material as a starting point, as most artists do. (Keep in mind that reference is different from copying!)

What does a dragon look like? I took the time to think about this question, and the first picture shows what I think a dragon would look like, in a simple flat shape. I visualized how all the parts would fit together. How would the tail connect to the body? How

Imagine your subject, and draw its shape.

would a dragon hold its head? I sketched my idea lightly.

Then I began to add details, working again from my imagination, with a simple line, starting to get some solidity in the drawing.

Finally I began the finishing process, using most of the techniques

Use line to add details.

we discussed earlier and creating the bigger drawing to the right.

Different parts of the big drawing are at different stages of development. You can see that I developed the feet farther in outline only, and pretty much ignored the first rough indications of feet in the beginning shape. Here and there on the surface of the body, you will note light lines suggesting my search for the form and texture of various parts. These lines simply guide me in the later stages of finishing up and might even be drawn over or erased in the final rendering.

The head and top of the neck are pretty much finished. I used mostly sculptured modeling here to give my dragon form, but there is some attempt to get a little light on it as well. Look where the bumpy texture and scaling show at the back of the head, neck, and lower jaw. This texture is more pronounced where the light hits the form at an angle; the bumps form their own little shadows. Where the light hits the form straighter on, it washes out the texture; be sure not to give equal emphasis all over or your drawing will look flattened and overworked.

After this drawing was ready, I put it on a gray background and added some soft highlights, to show you how to expand your apparent range of values. This is very similar to drawing on gray paper. Use these highlights very sparingly, or they will spot up the whole drawing and ruin it.

There is much that is unnatural in this drawing, but it shows that, by using pure knowledge and imagination, you can draw anything you can conceive of so realistically as to make it totally believable. Good fantasy illustrators use reference pictures to boost their knowledge, but when they draw, it is their well of experience and knowledge of their subject that comes through.

Refine the picture, adding tone and highlights. This is what I think a dragon looks like. What do you think a dragon looks like?

Foreshortened Views

Are you ready for one more level? This time we will be working on the edge between the concepts of a flat shape and a solid form.

Let's consider the full depth of our subject. Imagine that the dragon is coming straight out of the surface of the paper. Now it is considerably more difficult to imagine the flat shapes of your subject, and it requires a great deal of probing and searching with your pencil to get the basic shapes down. It also takes a strong ability to visualize your subject as you go along.

To get good results, you will need a lot of drawing experience, especially an understanding of rendering solid forms, as well as a knowledge of your subject or some good reference material to study. (However, if you are using reference material, do not copy it. Change the view drastically so that you are forced to develop your own powers of visualization.)

In the drawing on this page, I left in all of the searching lines and shapes, many of which I later rejected as I went along.

You might be thinking that I am contradicting myself here. Early in this book, I urged you to think in shapes first, then add form. Now I seem to be asking you to visualize solid forms at the very beginning. But really, this is not contradictory for several very important reasons.

First, when working purely from imagination, you have no shapes in front of you to look for, so you are forced into visualizing the three-dimensional aspects much sooner than you would be if you were looking at a model. Although I think it might be a good practice for many artists, I never have recommended that you eternally work in the same way over and over, always thinking "flat" first, no matter what situation or subject. Sooner or later, you will develop your own way of getting into a drawing. My strong emphasis on shapes is strictly because so many artists have never learned or understood this way of working and tend to resist it.

The act of drawing cannot be so simplified as to be packaged neatly into segments

Start by using searching lines to "find" your dragon.

that are clearly separated from one another. Once you grasp the principle of seeing flat patterns while you are laying out a drawing or working out problems of perception, you will be switching seeing modes constantly and unconsciously as you work. This is one reason for all the searching lines and exploratory work.

In the end, you still need to finish with a drawing that looks believably solid. But your ability to see shapes is so important that I am willing to risk overemphasizing it in order to drive home the point.

The drawing below is not the final level in working from the imagination. Your next step, if you were to continue in this direction, would be to do something more interesting to the pose of the dragon. Try turning its head more to emphasize the serpentine neck, and maybe bring one foot forward more. In other words, get your dragon even more lifelike. If you were using reference material, at this point you would be looking more at skin, scale textures, and interesting unusual features

that you could incorporate into your drawing to add realism. You could even build a little clay model to study dramatic lighting effects as you add the final touches.

If you feel more comfortable with flatter, more "designy" approaches, you should now be experimenting with more abstract ways of pushing shapes into understandable themes. If you still have no feel for these more realistic modes of working, give your own inclinations a chance.

One serious word of caution. Do not get in the habit of working only from imagination before you have developed your art enough to know what you want. You risk developing a strongly stylized way of seeing things, and your work will always look fake—just like my dragon does.

Work often from a model, or actual scenes, and humbly search for the truth of the shapes as they are presented to you. When you stop looking and thinking, you stop growing. Nature is still, and always will be, the last word in real art. Let nature guide you.

Add to the "realism" of your dragon or other fantasy creature by studying photographs of a lizard's skin or super-enlarged pictures of insects.

Perception

I have just given you two diametrically opposite ways of working purely from imagination. At the one extreme, you let accidental shapes suggest something to you, and you developed these shapes by adding little clues to emphasizing certain qualities and create recognizable objects while still retaining the basic flat pattern. This results in the viewer having to make the pleasurable leap of adding some of his or her interpretation to the image, thus personalizing the viewing experience.

*Express your own natural way
of seeing and drawing.*

On the other extreme, we started out with an idea and a recognizable shape, and developed them as far as we could by sheer imagination, leaving little more for the viewer to do.

The most common and logical way to work is by starting with a model, whether your model is an actual scene, or a figure, or a picture of something that inspires you. This greatly expands your possibilities. After all, we are all limited in our knowledge, experiences, or memories to draw from, and the viewer will not know or care if you worked from a model, a photograph, or your imagination. All that matters is the final picture.

Some of you found it easier to work in flat, stylistic patterns, and others embraced the solid, three-dimensional approach more naturally. This is where you will find your natural style lurking, and you should nurture it.

Van Gogh, Rembrandt, El Greco, Klimt, Corot, Matisse, Modigliani, and Picasso are just a few examples of great artists whom you could study for their individual interpretations and varied handling of shapes. Illustrators from Norman Rockwell to Dean Cornwall, N. C. Wyeth, Bob Peak, Al Parker, and many more are also excellent sources of study.

Finally, the cartoonists and caricaturists, too numerous to mention, provide endless proof of the use and power of simple shapes. The cartoons here were inspired by the works of other artists. They are not copies, but, looking at the original work, I studied the artists' use of shapes and imitated the basic style. Look for the simple basic shape combinations in these and other cartoons, and you will find that it is easy to emulate any style by starting with undetailed, sometimes almost geometric shapes before you draw any details. Of course, it is one thing to emulate another artist's work and quite another to create your own. Yet all of the artists who ever lived had one thing in common: They all worked with simple shapes, consciously or unconsciously. The difference between artists is simply that each one has his or her own personal way of seeing and creating. Yours might be yet another unique approach to add to the list.

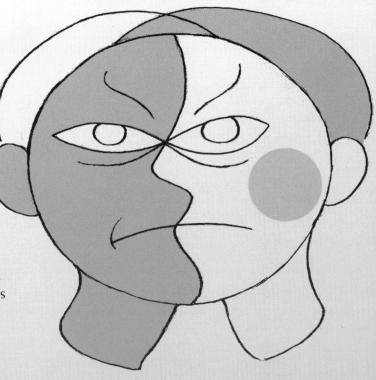

8 Shapes in Perspective

As an object gets farther away from you, it gets smaller. That's perspective in a nutshell. Fortunately, nature is full of irregular shapes and uneven vistas—and so, as an artist, you have some freedom to arrange things the way you like. Learn the basics, then use them to create your art.

Understanding Perspective

Every line that represents an edge going back into space in your picture is affected by the laws of perspective. As an object gets farther away from you, it gets smaller, until it reaches the point where it disappears at what is called a vanishing point.

It would be easier to explain these laws if we were living in an entirely human-made world where everything was level, squared up, and oriented in the same direction . . . but we are not. The real world is made up of hills, valleys, high mountains, and every other conceivable configuration. To top that off, we are constantly changing our viewpoints by turning or moving our heads. However, when you make a picture, the points are fixed. So we simply need to understand the laws of perspective and make allowances for deviations from the geometric "ideal" as we work.

Fortunately, nature does not cooperate with the human penchant for flat, level, squared-up vistas. So, outside of cities, landscapes usually hide flat horizon lines and mountains or trees are not perfectly vertical. This gives the landscape artist much more freedom to arrange things.

Imagine looking down a perfectly straight road. If the road stays perfectly straight, things are simple, but as soon as it turns, the way a river or a path does, or goes slightly up or down grade, things get complicated.

If the road is perfectly straight, the two lines representing the edges of the road gradually converge until they come together at a point on the horizon, just as every other line in your picture that is parallel to the road will converge at this same point, no matter how big the objects these lines represent are. Knowing this, and using basic logic, will help you to project and place any object properly into your picture.

In talking about perspective, I am going to show you only what you need to draw freehand. You will find that you often have to bend the rules to get a better design in your work.

Every picture or scene has an eye level. Consider the eye level first; you need to think about it before you put your first line on the paper. The eye level is simply a horizontal line that represents the height of the viewer's eyes as he or she views the picture.

The eye symbols in my examples represent the vanishing points, where lines converge. The view line (which is vertical) is the viewer's position (left to right) relative to the eye level. The point where the view line intersects the eye level is the vanishing point in one-point perspective.

There are basically two ways to consider a view in perspective. The first way is simple one-point perspective, also called parallel perspective. Visualize this by imagining yourself looking straight at the far wall in a room that has parallel sides. Imagine that everything in the room is in boxes and is lined up with the walls; nothing is placed at an angle. Every line that represents the edge of a box or wall would either be horizontal or vertical, or would point to the same single vanishing point on the eye level.

If you looked at an angle to the walls and boxes—that is, if you stood toward a side rather than straight in front of the picture—you would have two-point perspective. Everything would converge on two vanishing points, both found on the eye level.

If you tipped anything back or forward at an angle in two-point perspective, its vanishing points would move off the eye level. Since most scenes consist of things viewed at different angles, we normally have *at least* two different vanishing points in a picture. But as long as everything is level, all the vanishing points fall on the eye level.

Single-Point Perspective

This drawing of squares of tile in different positions demonstrates some important points. First, note that all angled lines point to the intersection of the eye level with the view line, a vertical line that represents the viewer's position relative to the eye level. All other lines are either horizontal or vertical. This intersection is the vanishing point.

If you were to view the tile horizontally exactly at the level of your eye, it would look like the central figure. You could see neither the top nor the bottom. Only the edge would be visible. When the tile is above eye level, you can see the bottom—the shaded areas in the top two tiles. When it is below the level, you can see the top—the shaded areas in the bottom two drawings. When it is viewed vertically, if it is to the left of the vanishing point, you would see its right side. When it is to the right of the vanishing point, you see its left side.

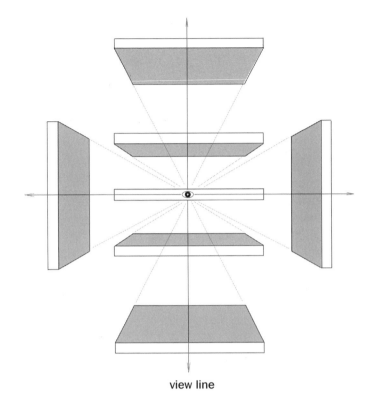

view line

Multipoint Perspective

You will usually use two or more vanishing points when you draw, so think of two-point perspective as a type of multipoint perspective.

This is an illustration of a room with eight boxes. All except one are lined up with the walls. That box, because it is turned, has two additional separate vanishing points still on the eye level. If we turned all of the boxes at differing angles, we would have sixteen different vanishing points, all on the same eye level.

Note the four parallel boxes to the left of the vanishing point. They are starting to show distortion because they are too far from the vanishing point in one-point perspective.

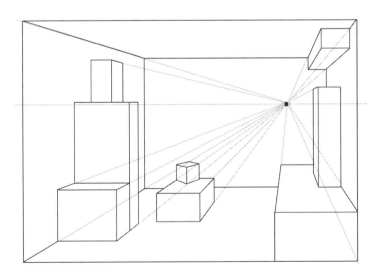

Using Perspective

When drawing freehand, we all tend to overdo the sides of objects that show depth (in the illustration on this page, the shaded areas), especially those that are near the vanishing points. Notice how little depth shows in the top three tiles. In fact, the tile at eye level has no depth at all. Yet when you look at the drawing as a whole, they all seem to suggest squares, and the spaces appear to be cubes. The key to getting them to look right is in getting the one farthest from the vanishing point to look right first and then building off of it.

If I had started this drawing anywhere else, it would have looked too deep by the time I projected everything down to the bottom tile. Remember this when you draw buildings or other boxlike shapes freehand without the benefit of actually scaling it up. Get the area farthest from the vanishing point to look right first and work in from there.

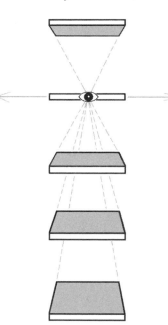

This picture shows the same grouping, but now we are looking at it from nearer the floor. This time you would draw the top tile first—it's the farthest from the vanishing point—and project the others from it.

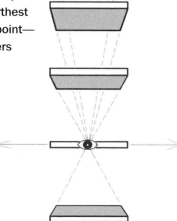

This illustration shows how this arrangement works with vertical planes. Everything remains the same, except the tiles are now vertical planes instead of horizontal. In this case, you are viewing the tiles from a point that is at their mid-height. You still draw the farthest-away tile first—in this case, the one at the right.

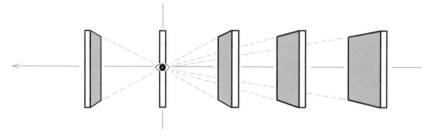

Now you, the viewers, have moved over a couple of tiles to look at the arrangement, and you have changed your eye level to line up with the tops of the tiles. Note that the top line of the whole group is now a straight line. You would still draw the tile farthest from the vanishing point first.

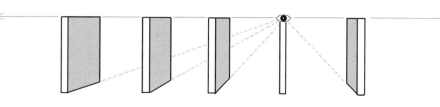

Understanding Multipoint Perspective

This drawing simply shows that you can place the whole cube above or below the eye level.

In two-point perspective, you can place objects without distortion anywhere within your cone of vision—that is, the area that you can see without moving your eyes. However, if you get too far from the object, you get the same distortion that we got by straying too far from the vanishing point in one-point perspective. At some point you would have to create a new vanishing point for the vertical lines, this time on the view line.

A good example of this is when you stand in front of a tall building and look up. The sides actually seem to taper as you look up at the top. If you were standing on the top of the building looking down, the lines would taper down.

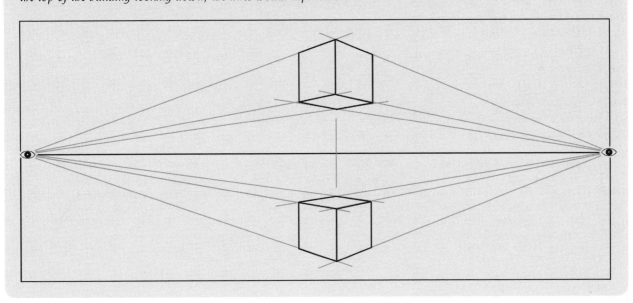

Distortion

Because of the limitations of our field of vision, we need to move our heads to see anything clearly that gets too far from where we are actually focusing our eyes—in one-point perspective, we are focusing on the vanishing point.

When we change our focus to either side to get a clearer look, we are actually moving our vanishing point. We are now really looking at the object at an angle, and we are creating an additional new vanishing point, so both sides appear to be receding from you. This makes one-point perspective really accurate only when the vanishing point is located in the center of

your drawing, and when you are looking at the subject exactly straight on, at a right angle.

Look back at the drawing of multipoint perspective on page 137, and you will see that since the tops and bottoms of the boxes to the left of the vanishing point are parallel, they do not recede. This is distortion; the lines do not strictly follow the rules of perspective. The farther the lines fall from the vanishing point, the stronger the distortion. Note that the three boxes on the right are not distorted. This is because the vanishing point lies close to the vertical edges of these boxes.

Scaling and the Grid

Let me show you how to reproduce, enlarge, or reduce any shape, or put it into perspective, with enough accuracy for most situations.

This type of grid, using diagonals, offers a far more efficient, if slightly less exacting, way of scaling your pictures than the conventional method of making tiny little squares. This is basic but valuable information that you will use many times in the future. I know it has saved me countless hours as a commercial artist when I needed to scale up or redraw a shape quickly. With it you can lay the graph into a perspective view and project it anywhere into a picture. By doing this, you can accurately project any shape onto any plane in your picture.

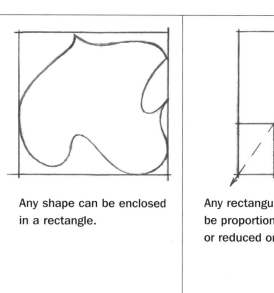

Any shape can be enclosed in a rectangle.

Any rectangular shape can be proportionally enlarged or reduced on its diagonal.

Diagonals from the corners of any rectangular shape cross at its exact center.

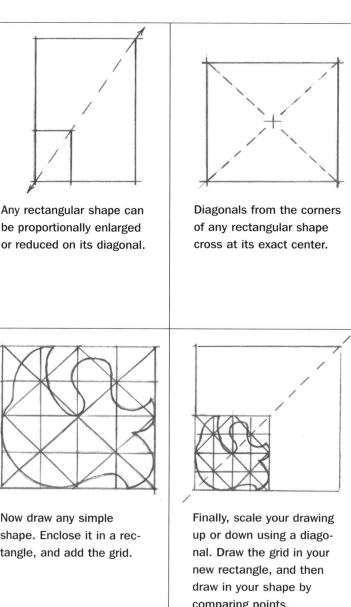

Make a grid such as this out of any rectangle. Put in the diagonals first; they will help you place everything else.

Now draw any simple shape. Enclose it in a rectangle, and add the grid.

Finally, scale your drawing up or down using a diagonal. Draw the grid in your new rectangle, and then draw in your shape by comparing points.

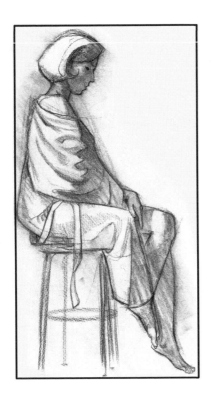

Here is another example. Let's say you had drawn a picture of a woman and you wanted to scale that picture up or down or change the proportions. You would make a suitable-size rectangular grid with diagonals. Then you would lay it over the drawing of the woman. Now the grid lines show you exactly what you need to do to make the whole drawing larger, for example, or smaller but in the same proportions. The middle drawing below also shows how to use the grid to put the shape into perspective.

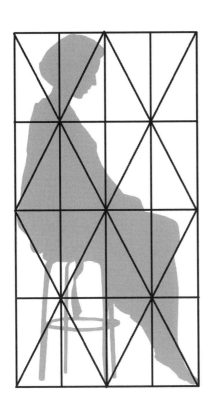

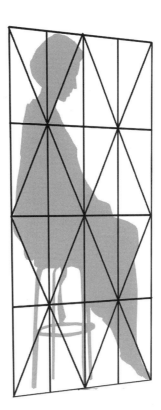

Single-Point Perspective Grid

With the grids here and on the next two pages, you can get the feel of how things work if you have never drawn in perspective before. Work freehand if you can, but use a T-square and triangle or ruler if you feel the need. (I did some of the drawings in this chapter by sketching them in lightly in freehand and by eye first, then cleaning them up with rulers and on the computer.)

An Exercise

To start, just place a sheet of tracing paper over the blank grid on page 143 and draw in pencil on the tracing paper. Try things such as I have done on the drawing on this page. Work with pure cubes for your first few drawings, and try to get them to look like cubes. You don't have to stick exactly to the angled lines on the grid, just follow them in their general direction. Work near the vanishing points and away from them as well.

Later, you can try rectangles and other geometric shapes. You can turn the book sideways or upside down to get different effects. Note that there is less problem of distortion in these views. Note also that it is easy to get your cubes too deep, so they look more like rectangular boxes. Pay special attention to the differences in depth as you work farther from the vanishing points.

Do not put too much time into working over these grids. I have included them to give you a sense of how the lines all converge at their proper points. When you have done this a short while, you should get back to drawing freely by eye as much as possible. You will find that you have a natural sense of where the lines should point; and working with these grids, then practicing on your own, will help you develop that sense.

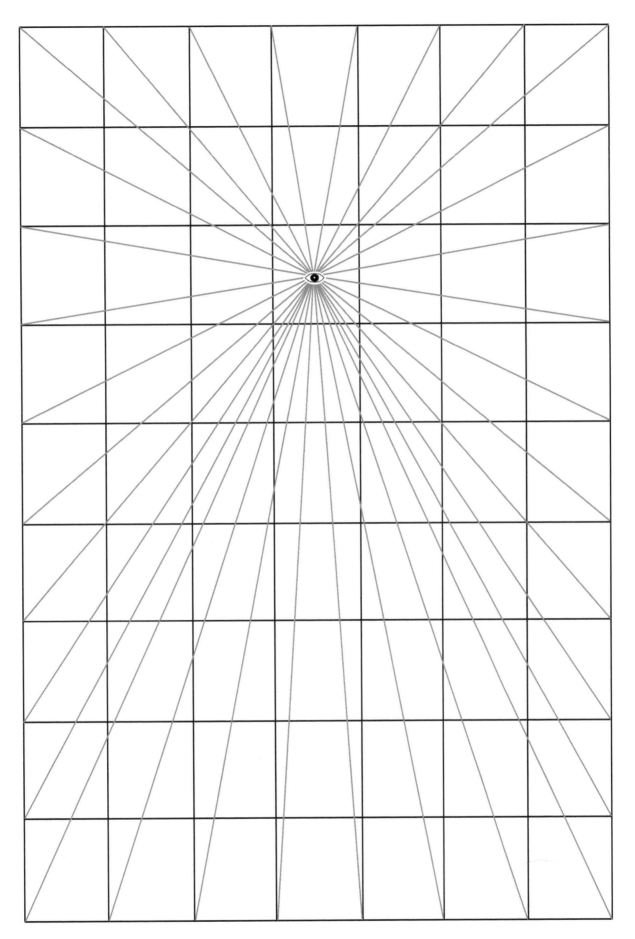

Multipoint Perspective Grid

Here is a two-point grid for you to play around with. One of the vanishing points is far off the bottom of the page. Again, remember that you can turn the large grid upside down or on either side to change your point of view. Notice that there is a completely different effect from each of the viewpoints—sometimes the viewer gets the feeling of looking up, sometimes of looking down.

An Exercise

Do the same experimenting with this grid as with the previous grid, shown on page 143. Laying a piece of tracing paper over page 145, start out by drawing cubes. There are ways to do this very accurately, by mechanical means; but for now, train your eye by trying to visualize things (including cubes and other geometric forms) without too many formulas.

You will notice that my lines are not evenly spaced. This is to force you to make some of your lines by eye in between my lines. If the lines were all evenly spaced, it would be a simple matter of counting the spaces to make cubes, and that would take away some of the benefits of this exercise. There are no cubes in my example on this page. Did you notice that without me calling your attention to it? If so, you may be fairly sensitive to proportions already.

Now you will be able to work out most perspective problems that you are likely to encounter. You simply have to use the logic from one situation and apply it to the next one as you go along.

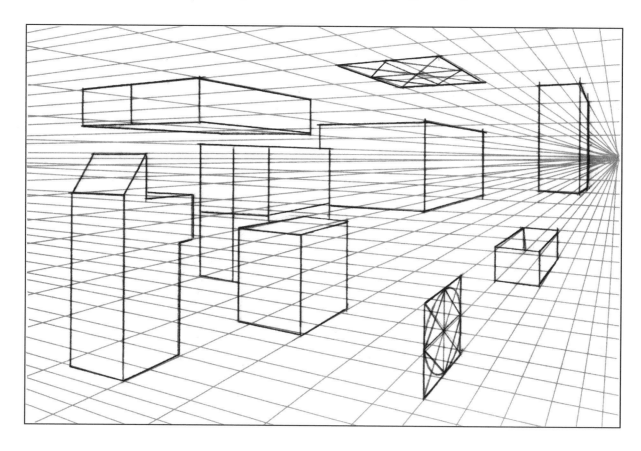

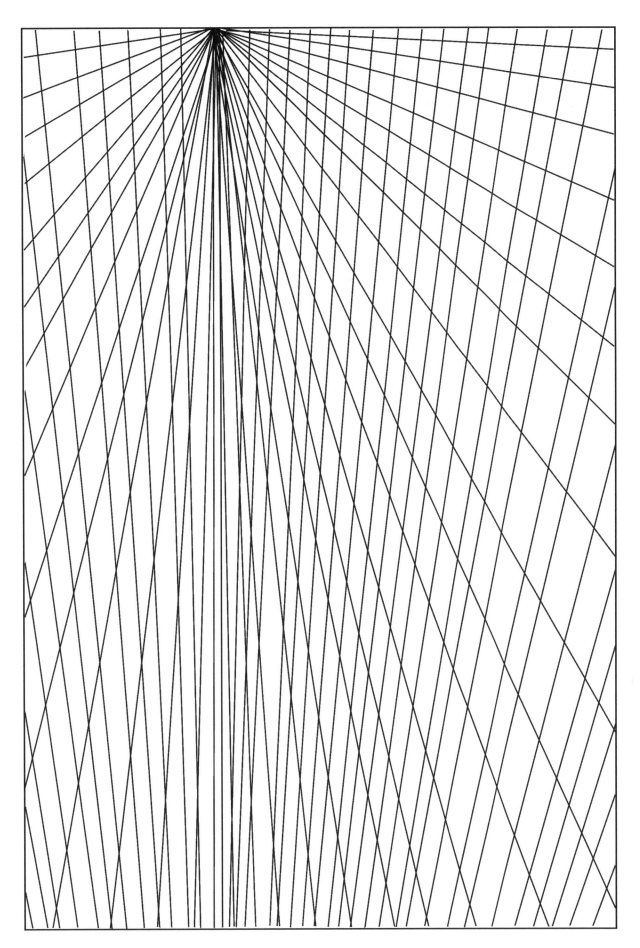

Projecting Shapes Back into the Picture

Learn to draw repeating rectangles. Then, using perspective, you can project them into your pictures.

To draw repeating rectangles, start with a single rectangle. Then draw two diagonals, making an X. Add a center line through the middle of the X. Now a line placed diagonally through the point where the center line crosses the far side of the original rectangle will repeat the rectangle where it crosses an extension of the side line. This can be done on any rectangle in any position. It is good for placing things such as fence posts or other evenly spaced things.

As you learned in the section on scaling, the grid can be placed on any rectangle drawn in perspective, and any shape can be transferred to it. Below is the shape we used as an example in scaling. The big problem is getting the proportions of the rectangle to look right first.

This is a good method for drawing circles in perspective. Draw a circle with a compass, and put your grid around it to see how it works in a straight-on view before you project it.

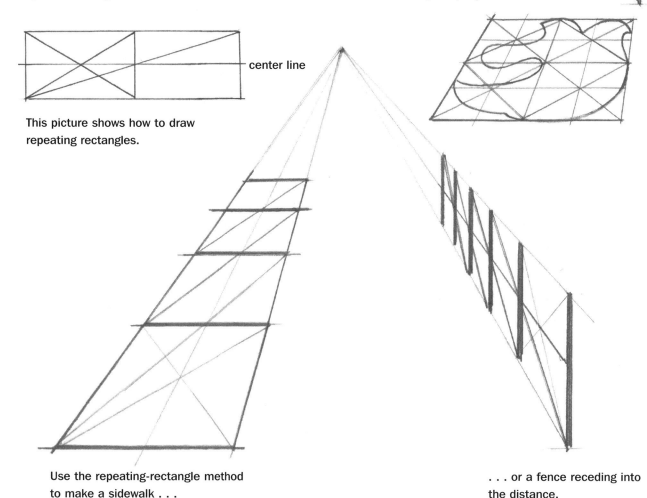

center line

This picture shows how to draw repeating rectangles.

Use the repeating-rectangle method to make a sidewalk . . .

. . . or a fence receding into the distance.

Using the Multipoint Grid

This is a rough visual of a cityscape using the two-point perspective grid and simple geometric shapes. You can see the possibilities for developing shapes into buildings using simple perspective knowledge. Notice how even the rough cloud lines follow the laws of perspective and add to the sense of depth.

There is a great deal more to the study of perspective than what I have given you here. I found it to be a fascinating study, and I strongly recommend that you get a couple of good books on the subject, and learn more about it. I have listed some of my favorites on page 160.

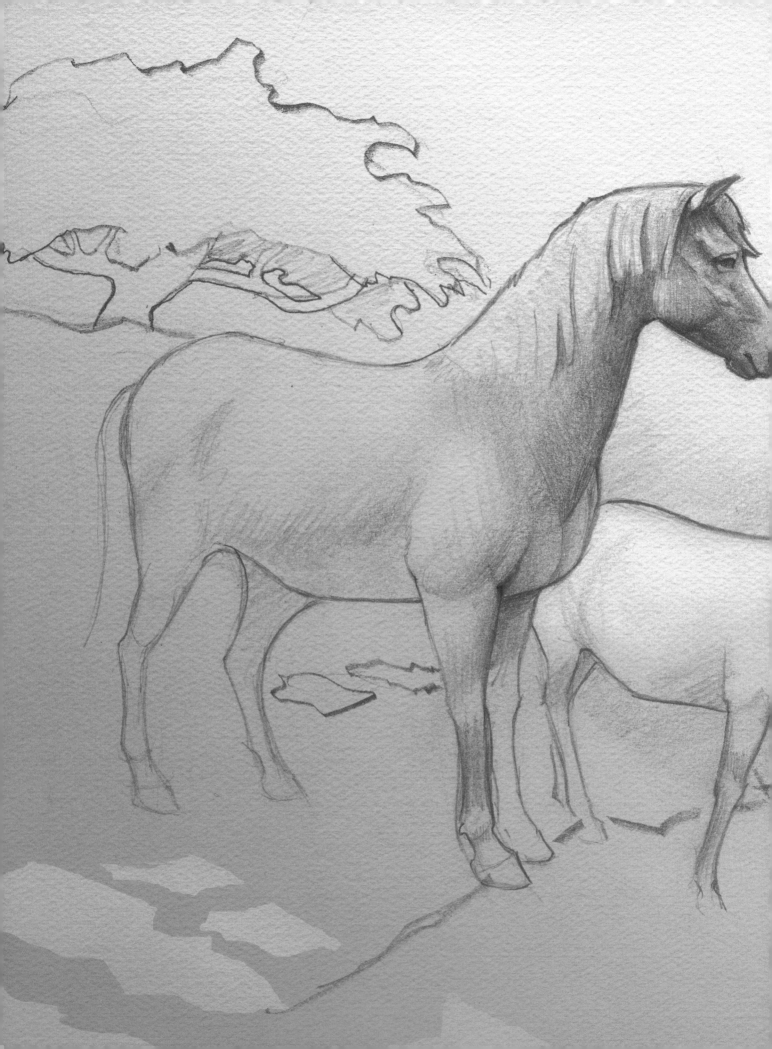

9 Design

What attracts you to one drawing over another? It is the design of the basic shapes of differing values, colors, and textures. Discover the properties and principles of design in this chapter and make them part of your drawings.

Understanding Design

Walk into any art gallery and stand in front of a wall of paintings. You will be immediately drawn to certain pictures even before you can tell how well they are drawn or painted or what the subject is.

It is strictly the organization, the design of the basic shapes of differing values, colors, textures, or edges in the painting that attracts you.

If the organization of the shapes is bad, a drawing or painting is doomed before you can even begin. No amount of flashy work can save it. Yet it is my belief that when working realistically, design often is best left to your subconscious.

Design is so strongly linked to your style of drawing that the two are difficult to separate. Design and style are not the same thing. Style cannot be taught; it evolves by itself. Your "style" is determined by a combination of all the things that make you an individual. Your style is yours alone; no one else in the world perceives things and puts them on paper exactly like you. When you are working realistically and you make style the major subject of your attention, the results often look forced; and when that happens, you dilute the message of your work.

Let your style develop naturally. It doesn't hurt to study the works of others that you like, but never put out that little fire that tells you to do it your own way, no matter what may be popular at the moment.

Many artists, and most illustrators, make little rough compositional sketches before they start on a final work. This way they have a general plan and can make things all happen at the same time as they work on the final piece. Often enough, these early rough sketches are modified sufficiently in the final piece so as to become unrecognizable.

To me, nothing seems so ridiculous as watching the "art expert" move through an exhibition expounding on the supposed compositional intentions of a long-dead artist as he or she made a particular work of art. The good artists that I know make a rough plan; in fact, some make a dozen or more little roughs. But when they get into the final piece, their major focus is on what they want to say, and they make many design decisions intuitively.

Most of us have a strong sense of "rightness" when it comes to composition, and it is wise to pay attention when you are uncomfortable with the arrangement of the elements in a piece.

You can develop this built-in sense by constantly studying other works. Analyze the things that you see out there in terms of composition or organization to understand why they affect you in a positive way. Don't get in the habit of looking only for mistakes. Look for drawings and paintings you like, and try to understand why you like them. Use your own criteria for judging them. Only by listening to the small voice that is already in you will you be able to make your own personal contribution to the growing body of beautiful art out there. Nurture this sense and help it grow to its full potential so that it can guide you as you work without conscious effort. And keep your mind open to new ideas.

There are basic laws for the order of all things, and this is true of the visual arts as well. There is a price to be paid for breaking them, so it is wise to get as thorough an understanding of them as possible.

My view of design is guided by my belief that shapes are not simply another element in a drawing or painting. Traditionally, shape is lumped in with all of the other elements of design—but since the shapes actually contain all of these elements, they deserve a special role.

Here's one of the best ways to get a feel for the power of design. Take two L-shaped pieces of cardboard. Place them over an existing picture to crop it into various sizes and proportions. Try all different crops; you will often find far better designs than the original picture had! As you experiment, notice how a few big, simple elements—shapes—will usually create a better, more powerful composition than more complicated, busier designs. In the horizontal crop, notice how tension is created by the off-center placement of the model and the deep shadow behind her. The vertical crop has a greater sense of intimacy and reflection than the original.

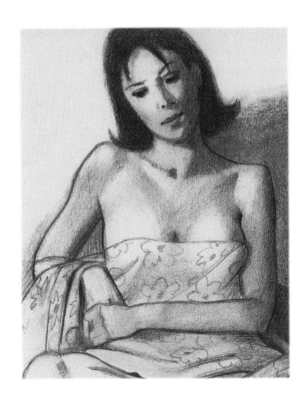

Properties

Composing a painting or drawing is nothing more than the control and manipulation of shapes. All of the so-called elements of design are actually the properties of the shapes.

Color, value, texture, orientation, and size are properties of shape. Line must also be considered at this point, too, since the edges and contours of shapes are often lines. Line offers some special properties of its own, but for our purposes we will consider line simply another property of shape, giving us six properties to work with.

Let's look at these properties individually. Every shape has every one of the six properties.

Value A shape's value is simply how light or dark it is.

Texture A shape's texture can be smooth or rough, or something in between.

Orientation Orientation means that the shape is horizontal, vertical, or diagonal, or that the shape feels horizontal, vertical, or diagonal.

Size A shape's size is relative, as compared to the shapes around it.

Line Line is different from other properties of shape. Yet shapes have edges where they meet other shapes, even when the shapes are not outlined, and these edges form directional lines.

Unity, variety, balance, dominance, repetition, harmony, gradation, and conflict are the eight ways to modify and organize our shapes. These are the design principles, tools for organizing the shapes or their various properties. (We will look at principles of design in more depth on page 154.)

Generally, when these principles are ignored, the design of the piece suffers. The problem is that when you become too consciously involved with properties and principles during the actual process of making art, you are likely to miss some of your own natural insights. So my recommendation is that you study and understand these principles until they work automatically for you. Make little rough, quick studies before you tackle a major work; but when you are actually creating art, concentrate on your message, or the thing that inspired you to make this particular piece, and use the principles to analyze and improve it later, or near the finish, or as problems arise.

Every work of art should have a message, or purpose, or emotion that the artist wants to convey to his or her viewers. That message should be the prime consideration of the artist as he or she works. Design properties and principles are simply tools to help bring this message to the viewer as simply and dramatically as possible. They are meant to help you express yourself as an artist. If these properties and principles get in the way of expressing your idea, it is likely that you do not clearly understand the properties and principles. Nevertheless, you are the artist. Do what it takes to present your message clearly, even if you think you are violating the principle.

The properties and principles that I am discussing in this chapter are basic guidelines that have stood the test of time. Use logic when you violate them, but do not hesitate to do so if your inner voice strongly tells you to do it.

Often these properties and principles can be used after you finish a work to help you decide why you are dissatisfied with a painting or drawing. They may even guide you to a solution.

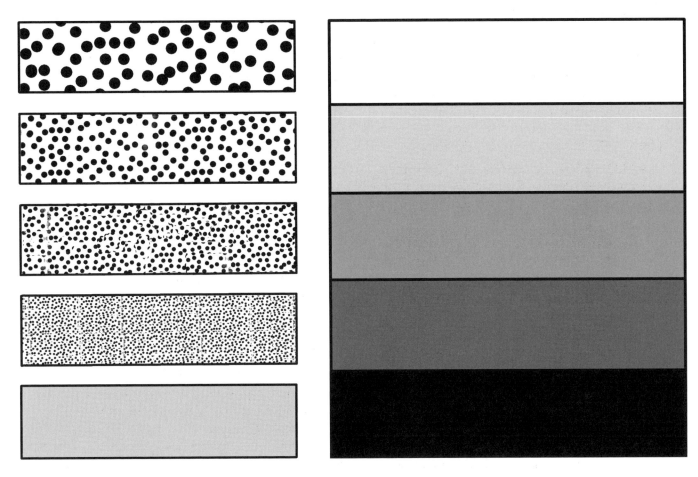

Gradation of texture, rough to smooth.

Gradation of value, light to dark.

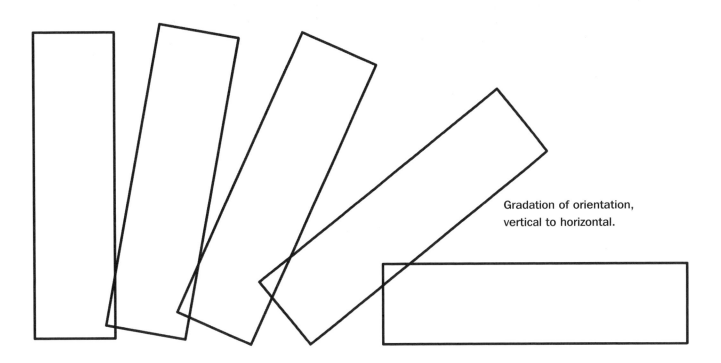

Gradation of orientation,
vertical to horizontal.

Principles

Let's take a closer look at these basic design principles, introduced on page 152, and see how they apply to each of the elements and ultimately the shapes of a composition.

Unity is the big player among the principles of design. At least half of the other principles serve to help assure it. Unity is oneness. When a piece is unified, all its parts come together as one whole unit.

Nature unifies her shapes by many means, and it is the final word in beauty. When nature lowers the light, it gradually fuses the parts, always keeping the whole as a unified thing. Think of the island again.

When a farmer paints a barn out in one of nature's beautiful landscapes, nature immediately begins to work on it to gray down and unify all the contrasting colors, bringing them together into a beautiful simple silver-gray. Think of stones and pebbles on the beach. Nature is constantly grinding and shaping them into ever rounder and smoother, more closely related shapes, unifying them over time.

There are countless examples of this most important principle of visual order out there, if you will look for them. Consciously look for this quality of oneness in all of your work.

Repetition is like an echo. Softer echoes are intriguing; stronger echoes are startling. Repetition should not be too obvious, but a subtle reminder of the thing repeated, adding to the unity of the whole by the familiarity of the parts. Shapes can be echoed; so can any of their properties.

Variety is needed to avoid boredom, but it is easy to overdo it. Apply this principle with taste, or you could destroy the unity of your piece. Variety should also be considered in each of the properties, as well as in the shapes themselves.

Balance breaks down into two basic types, symmetrical and asymmetrical. Each triggers different emotions in viewers. A lone spot in the center of a canvas balances the artwork with a totally different feeling than two spots of differing sizes placed to balance each other on the same canvas. Balance is easy to achieve in your work with a little thought.

Symmetrical balance can be boring if it is not used appropriately.

Dominance is another major player, right up there with unity. You cannot have more than one top general in any army, and without that officer there is chaos. Every single property of shape, including the shape itself, should be carefully considered to be sure that one element of each is dominant. The proper use of dominance practically ensures unity in a piece and goes a long way toward helping with all the other principles.

Harmony means "family." Things that have something in common are harmonious to the degree that they are similar. Middle gray and black are more in harmony than white and black, which are opposites. Dark gray and black are more in harmony than middle gray and black, and so on. Circles and ovals are more harmonious than circles and squares. Perpendicular lines are more harmonious with diagonal lines than they are with horizontal lines.

Gradation is not only a transition from a light to a dark; it is also a transition between any two colors, textures, shapes, directions, lengths, angles, or sizes. It adds harmony and unity and softens conflict between two opposing factors.

Conflict is the result of opposition. It can add spice to a composition, but too much can also

destroy unity. Any of the elements of design, at the opposite ends of their spectrums, are in conflict. Dominance is one tool that can modify conflict; so is gradation. Use conflict sparingly, unless it is the theme of your work.

These are the eight principles that you can look for to help you judge your work. They must be present to varying degrees in any meaningful work of art, as well as in each element of the work.

The principles of design are universal, and when they are not followed to some degree, the result is often an uncomfortable composition. I used the word "uncomfortable" for a reason. A painting that produces an uncomfortable feeling in the viewer does not necessarily mean that the design is a failure. That uncomfortable feeling may be just what the artist wanted in his or her work, and so the rule of design might have been broken . . . but the painting could be considered a success. (This is the problem with rules in art!)

These design principles offer a way to analyze and correct problems in your designs; and when you understand them so well that they become part of your subconscious, they will guide you as you work to keep these problems from occurring.

No one can tell you exactly how to apply these principles. You still need to exercise your own instincts of taste, as well as logic and judgment. Many rules have been laid down, and often broken, as to the proper organization of these elements of design. We would develop a sameness and, ultimately, boredom in our compositions if we were bound by ironclad rules while we work. This is what makes explaining design so difficult. At the same time, it is also precisely why every piece of art is unique, and why some people seem to have an instinctive sense of what looks right while others have to work at it.

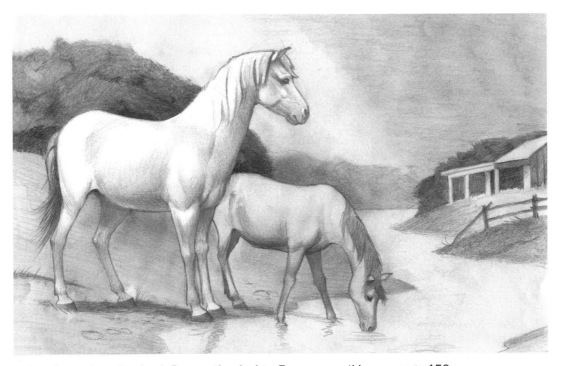

Living shapes in a drawing influence the design. For more on this, see page 156.

A Simple Test

By giving shapes their proper place in the hierarchy of your art, you gain a clear focus as you study. You also have a straightforward way to critique your work, or someone else's.

Here is a simple questionnaire that you can use to get right to the heart of design problems if you find something disturbing about your drawing or painting. Instead of beating around the edges of the problem, think "shapes." That will immediately put your focus on the area that almost certainly contains the problem. Then all you need to do is narrow the possibilities by this process of elimination.

Ask yourself these questions:

- Are your shapes clear and easy to "read"?
- Is one of your shapes dominant?
- Is the dominant shape too close to one of the edges of your picture?
- Is it positioned with a different measure from each border?
- Are all your secondary shapes the same size?
- Are there too many shapes in your picture?
- Are any of your positive shapes touching?
- Do you echo your dominant shape somewhere?
- Is this echo too obvious?
- Are the shapes too contrasty? Too conflicting?
- Are the shapes too close in value?
- Is there too much "sameness" between your shapes?
- Do your main shapes have variety in their edges?
- Is the big shape of your canvas appropriate to your subject?
- Is the drawing or painting properly divided into interesting subareas or grounds?

- Is there unity between the shapes?
- Is there variety among the shapes?
- Does the dominant shape let the background in by interlocking with it at one of its edges?
- Does the dominant shape let the background in by losing an edge somewhere?
- Is there a textural variety among your shapes?
- Does the dominant shape have different dimensions in its length and width?
- Does the dominant shape have a diagonal in at least one of its edges?
- Can most of your shapes be considered a family?
- Are your value chords appropriate to your subject? (A value chord is the interval, or step between three or more values. Here I am referring to the overall key of the drawing or painting—is it low (dark), middle (medium), or high (light)?

This list is meant to get you thinking about problems that arise in the design of a picture. The questions are not rules; they simply suggest a possible problem or solution to give you a focus and get you thinking.

Living Shapes

The shapes of people, animals, and other living things add new elements to your designs. Although the basic rules still hold true, these new shapes usually have much more interest than geometric shapes, and so they need to be considered carefully. W.C. Fields used to say, "Never work with kids or animals." He had a point—living things grab all the attention and add a dominance that is all their own. But as an artist, you should welcome the extra interest that organic shapes add to a drawing or painting.

In considering a drawing for the cover of this book, I tried a few sketches that were pure still lifes—all objects. One of these original sketches is shown at the top right. When I showed this picture to my editors, we all agreed that the picture needed a little extra spark of life in order to have the interest that a cover demands.

I already had a sketch of our cat reclining on a cardboard box—the middle picture—so I experimented with the drape. In my first few drawings, the cat commanded so much attention that he literally dominated the whole design.

In the end, I decided to put him in the background of the picture, behind all the other shapes. He took his place in the composition quite comfortably, I think, don't you?

As you gain experience as an artist, you will add some design ideas of your own, as well as eliminate some of mine. What is important is that you start thinking about design and its properties and principles from the logical starting point of the shapes.

One last thought to remember: Even when you are drawing one simple object, you are designing. When you draw a figure, you make decisions about how big you will make it and where you place it on your paper. These decisions have a big influence on how the viewer will be affected by your work. We are all guilty of ignoring this at times. Luckily, we can crop a drawing or even a painting to look its best after we finish it, but it is better to pay attention while we work.

Every time you put pencil to paper, you are making design decisions.

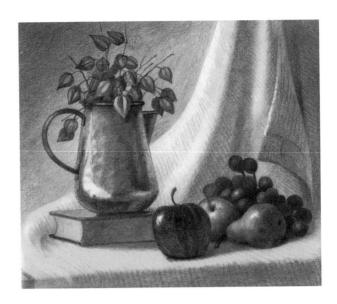

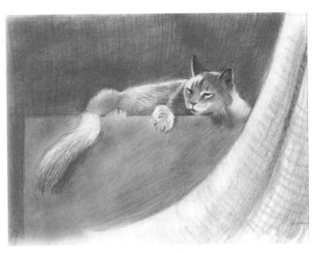

Think about both shapes—both organic and geometric—as you design.

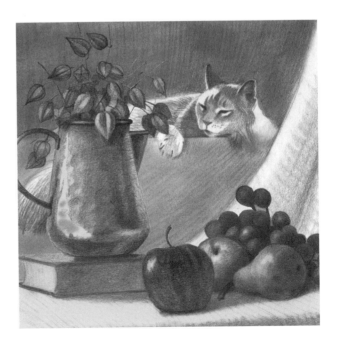

Time to Part

We have covered a broad spectrum of subjects in this book. Practically every chapter cries for a book of its own. As a result, we were only able to touch the surface of the subject of each of these chapters.

Putting these thoughts into words has been a real education for me and has only served to strengthen my belief that shape is everything. I leave it to you to continue this fascinating journey on your own.

If I have managed to awaken your sense of the simple shape and helped you to really see shapes in the things around you, then I know without a doubt that you now draw better than you could before you picked up this book. I also know that you are getting much more pleasure out of drawing and sketching than you did before.

After well over a half century of drawing, painting, and associating with artists, I realize that most of us have developed bad habits through the years. We spend the first half of our lives developing these habits and the last half trying to undo the harmful ones. The result is, most of us don't get very far.

It is rare to find the individual who gets progressively better and continues to grow without serious interruption throughout his or her life. Somehow, these people manage to avoid the traps that the rest of us fall into with regularity. Experience has shown me that these fortunate few have a special view of shapes, and that has provided their focus for their continued growth.

Art really is no different from any other endeavor, but for some reason, we tend to view the artist and the study of art differently from other professions. We feel that you either have artistic talent, or you don't. I have never quite been able to accept that premise, although, when I see an artist of thirty who seems to understand things that have taken me fifty years to figure out, and maybe I still don't have it right . . . well, I begin to wonder.

I have a special feeling for those artists who have worked for years without noticeable progress and still keep right on struggling.

Probably we all fall into that category to a greater or lesser degree, or at least we sometimes think we do. But every now and then, we manage to get a little breakthrough, and that keeps us going. For me, that breakthrough came when I began to see and understand shapes.

This is the secret that could help so many of those who are struggling. I have seen almost magical results in those who give these ideas an honest try.

Concentrate on the study of shapes. It is like having a road map to keep you from straying off course in your quest to find your place in the world of art. And the study offers a lifetime of exciting discoveries.

Whatever your level, wherever you are in your struggle to express yourself artistically—enjoy your art!

Index

Further Reading

Carlson, John. *Carlson's Guide to Landscape Painting*. New York: Dover Publications, 1973.

Chelsea, David. *Perspective! for Comic Book Artists*. New York: Watson-Guptill Publications, 1997.

Cole, Alison. *Perspective (Eyewitness series)*. New York: DK Publishing, 2000.

De Reyna, Rudy. *How to Draw What You See*. New York: Watson-Guptill Publications, 1996.

Edwards, Betty. *The New Drawing on the Right Side of the Brain*. New York: Jeremy P. Tarcher/Putnam, 1999.

Garcia, Claire Watson. *Drawing for the Absolute and Utter Beginner*. New York: Watson-Guptill Publications, 2003.

Henning, Fritz. *The Basis of Successful Art: Concept and Composition*. New York: Writers Digest Books, 1983.

Kraayvanger, Allan. *Figure Drawing Workshop*. New York: Watson-Guptill Publications, 2003.

Watson, Aldren A., and Ernest W. *The Watson Drawing Book*. New York: Dover Publications, 2003.

Watson, Ernest W. *The Art of Pencil Drawing*. New York: Watson-Guptill Publications, 1985.

Whitney, Edgar A. *Watercolor: The Hows and Whys*. New York: Watson-Guptill Publications, 1958.

Acknowledgments

A book is rarely the product of one person. I don't even know all of the great talent that contributed to this book, but my thanks go out to everyone involved. Thanks especially to those who have the power to make or break a book, and who use it beautifully, and wisely—my editors, Joy Aquilino and Laaren Brown, and my designer, Sivan Earnest. My thanks to all.